IMAGES
of America

MONTVILLE

IMAGES
of America

MONTVILLE

Jon B. Chase

ARCADIA

First published 2004

Published by Arcadia Publishing,
Charleston SC, Chicago IL, Portsmouth NH, San Francisco CA

Printed in Great Britain

Library of Congress Catalog Card Number: 2004106824

For all general information, contact Arcadia Publishing:
Telephone 843-853-2070
Fax 843-853-0044
E-mail sales@arcadiapublishing.com
For customer service and orders:
Toll-free 1-888-313-2665

Visit us on the Internet at www.arcadiapublishing.com

On the Cover: ROCKLAND MILL FROM THE SOUTH. Built in 1868, the historically significant "Old Stone Mill on the Oxoboxo" was acquired in 1875 by Carmichael Robertson, and for well over a century it was used to produce paper for the company he had founded. The mill was demolished in 2004 by owners Rand-Whitney. (Copyright Mystic Seaport, Everett A. Scholfield Collection, Mystic, Connecticut.)

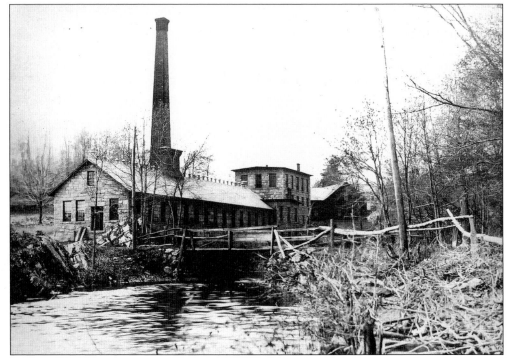

THE BANK MILL, C. 1900. The stone mills of the Oxoboxo are an enduring feature of 19th-century Montville, though their ranks are thinning. The remains of this one are now hidden behind 20th-century appendages. (Montville Historical Society.)

CONTENTS

ACKNOWLEDGMENTS

This collection of images would be greatly diminished without the many photographs graciously loaned by Charles Dennis, Faith Jennings, and Nancy R. Savin, but every smaller assistance and word of encouragement were equally valued. The cooperation of the Montville Historical Society, the Raymond Library, Mystic Seaport, and the Connecticut Historical Society is also very much appreciated.

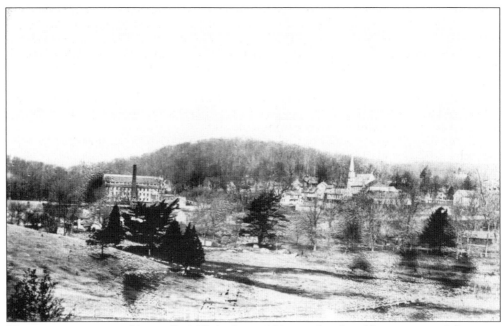

UNCASVILLE, C. 1880. Uncasville Mill, built in 1823, is today the oldest survivor of the many factories that appeared during Montville's industrial revolution. Located in a setting fit for a landscape artist, this New England mill village complemented its natural surroundings, but industry profoundly altered the relationship of people to the land. (Montville Historical Society.)

INTRODUCTION

Montville is a place of contrasts. From the tidal Thames River on the east, its hills rise to over 600 feet. Vestiges of a rural landscape remain, along with the changes brought about by once-thriving industries that are now mostly gone. But as the face of the town continues to change, now in ways few could once have conceived, old photographs reflect moments in time. The task of this book is to link such images to show the emergence of a town that is recognizably that of today.

Montville's past defines its present. American Indian land claims found their ultimate result in modern gambling-based development that has intensified the alteration of the landscape. Genius and entrepreneurial drive, besides geographical circumstance, once produced water-powered manufacturing worthy of marvel, but today the legacy of industry is more mixed. And all around the town, land once cleared for agriculture is yielding a final crop in the form of suburbia.

The goal of this book is not simply to take a nostalgic look at the way things once were but also to promote awareness of the significance of what remains, in the hope that informed planning may discourage future losses wherever possible.

The commentary accompanying this collection of images is often based on lengthy research. But such a book cannot possibly be comprehensive. There are countless more stories worth telling and past and present scenes worth noting. My goal is simply to provide a glimpse of Montville as it was, not to write its history. As such, my hope is to inspire the reader's own curiosity.

THE OXOBOXO VALLEY, C. 1880. In this view, looking northwest toward Palmertown from above Uncasville, the rural landscape descends toward tree-hidden industry. Pie Hill (at the left) and Pole's Hill (at the right), as they were then known, display fields and forest, respectively. (Faith Jennings.)

One

THE NORTH PARISH OF NEW LONDON

When New London was settled in 1646, Uncas claimed dominion over the land to the north of Cochikuack, or the lower Oxoboxo Brook. Samuel Rogers is generally acknowledged to have been the first English settler on the Mohegan lands within the present town of Montville, arriving from New London *c*. 1670. He had the benefit of large land grants from Uncas, with whom he was on friendly terms.

Uncas was succeeded by his son Oweneco. Large areas of the vast Mohegan lands throughout the region were conveyed with increasing rapidity to Englishmen and were sometimes gained by unscrupulous means. New London coveted all of the land south of Norwich, and in 1703 it annexed everything beyond Cochikuack (by then known as Saw Mill Brook) and as far north as Trading Cove Brook. Preferring autonomy with a pretext of social and religious order, the white inhabitants of northern New London petitioned the General Assembly to be allowed to proceed as a separate and distinct parish. The organization of its own church and the settlement of a minister were the requisite conditions for the establishment of the North Parish of New London.

SAMUEL ALLEN'S TAVERN, LATER THE "TOWN FARM HOUSE." Samuel Allen kept a tavern at his farm on the road from New London to Colchester *c.* 1720. The North Parish church was organized in the tavern's rooms in 1722, and the church's early religious services were held here before the first meetinghouse was built on Raymond Hill. Much later, and after many changes,

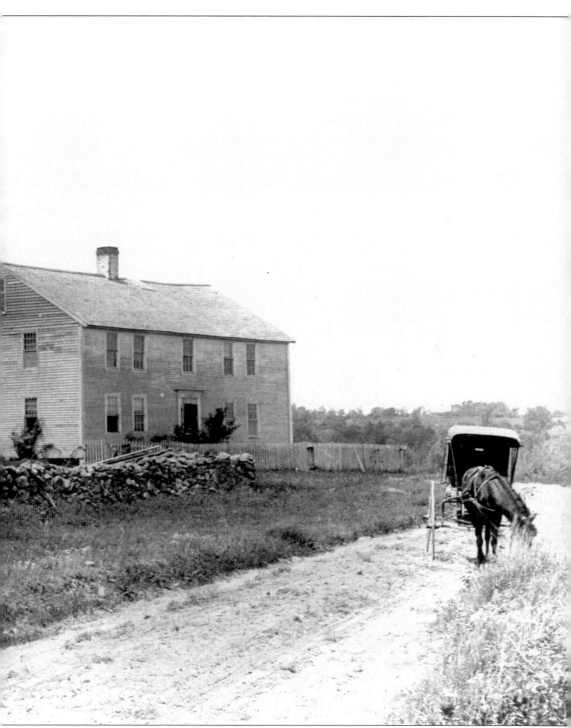

the old tavern became the town of Montville's almshouse. It burned to the ground in 1910, but a replacement was built, and the "Poor Farm" continued to house local paupers until the inception of welfare payment programs. This area is now Montville High School's main parking lot. (Connecticut Historical Society Museum, Hartford.)

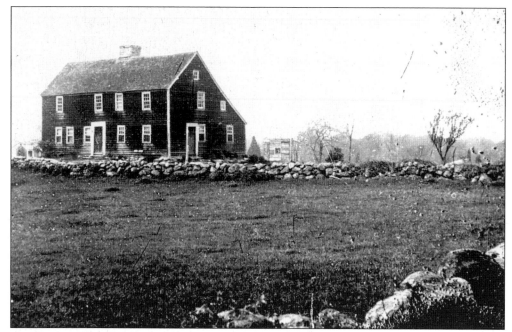

THE SAMUEL FOX FARM. In 1787, Samuel Fox, one of several early inhabitants by that name, inherited a farm along the Old Colchester Road. His house stood opposite the Town Farm, which is now the location of Montville High School. Sometime after this early photograph was made, the area in the foreground was used for paupers' graves. The graves remain today, overgrown and forgotten. (Montville Historical Society.)

THE FOX HOMESTEAD. An earlier Samuel Fox (whose father, younger brother, and son were all named Samuel) settled c. 1700 on a large tract of land owned by the family patriarch, and he built a house on a hill near the present Oakdale post office. His home was destroyed by fire c. 1760, and a grandson, Ezekiel Fox, then built the house seen here. It too is gone, but the Fox family cemetery is still in use nearby on Route 163.

THE JOHN RAYMOND HOUSE, MONTVILLE CENTER. This farm was part of the extensive 17th-century land grants to Samuel Rogers by Uncas and others. In 1698, Rogers gave a portion of his land to his daughter Mary Gilbert. This parcel, on which she and her husband had previously settled, was described in the deed as lying "west or southwest of certain planting fields usually called by or known by the name of Moheag." The Gilbert Farm was sold in 1713 to Maj. John Merritt and Mercy Raymond, who were then starting to assemble their vast "Great Farm" on Raymond Hill. The present house is attributed to John Raymond (1748–1828), who was the first town clerk when Montville was incorporated in 1786. He served for 16 years. (Connecticut Historical Society Museum, Hartford.)

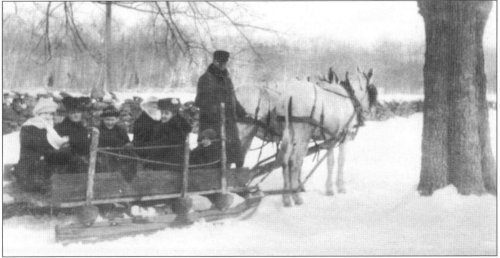

MONTVILLE CENTER IN WINTER This photograph dates from the 1920s, but the rural landscape was little changed from how it would have appeared two centuries before this sleigh headed east on Raymond Hill Road.

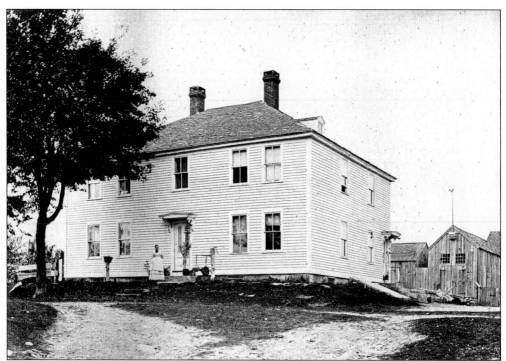

"The Great Farm on Which I and the Said Mercy Raymond Now Dwell." In 1713, Block Island widow Mercy Sands Raymond and Maj. John Merritt purchased this farm, described in the deed as being located "a little west of the Mohegan Fields," and also bought the adjacent Gilbert Farm. Soon they amassed several thousand acres. Mercy Raymond's wealth, legend says, was gained from provisioning Captain Kidd and boarding his wife at her isolated island home. In 1726, Major Merritt, whose precise social relationship to Mercy Raymond is unclear, sold his interest in "the Great Farm on which I and the said Mercy Raymond now Dwell," along with 11 slaves. Mercy Raymond and John Merritt gave the land for the North Parish church. Ardelia (Hyde) Bradford is seen here *c.* 1885.

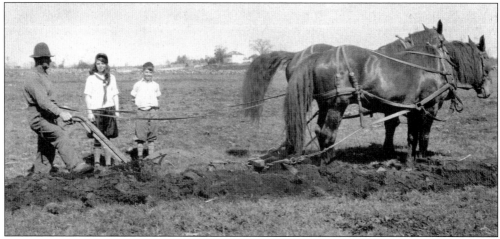

Spring Plowing. Paul P. Glasbrenner, whose mother-in-law is seen in the photograph above, carried on the farming tradition for over 50 years. Local children look on as he plows in the "Long Lot" with the old homestead in the distance.

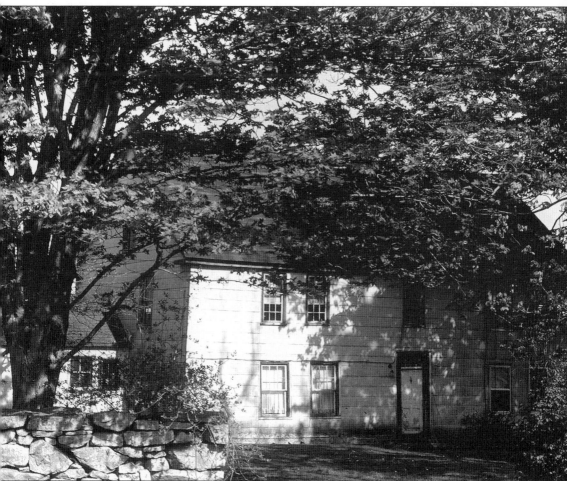

THE LT. JOSEPH BRADFORD HOUSE. Joseph Bradford was a land speculator, usually in partnership with Sarah Knight, a widow whose remarkable journal describes her 1704 trek from Boston to New York. In 1720, Bradford bought a half-interest in property "lying in the Mohegan Lands," having purchased half with Knight the year before. The land was part of a huge tract sold by Oweneco in 1710. The house Bradford built was standing by February 22, 1721; on that date, a commissioner's court convened here, having been empowered by the General Assembly to rule on complaints by Sachem Cesar (who succeeded Oweneco) that whites had intruded onto American Indian lands. After hearing the evidence, the court ruled in favor of most of the settlers. The old house on Fitch Hill Road has been restored since this photograph was taken c. 1980.

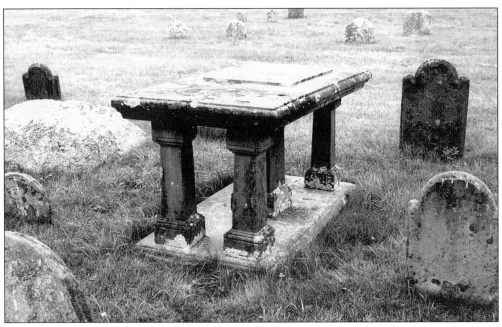

DIALOGUE,

OR,

Reprefentation of Matters of Fact.

Done in a plain and eafy Drefs.

By Way of Queftion and Anfwer.

Occafioned by fome Mifmanagements which happen'd in refpect of a Gentleman, whofe Affairs lay under the Confideration of an Ecclefiaftical Council.

Dedicated to all Unprejudiced and Impartial Perfons.

Prov. 30. 12. *There is a Generation who is wife in their own Eyes, and yet are not wafhed from their filthinefs.*

Printed in the Year, 1 7 3 6.

REV. JAMES HILLHOUSE. Born in Ireland *c.* 1687, James Hillhouse was educated at the University of Glasgow and ordained by the Presbytery of Londonderry, then emigrated to Boston. In 1722, he was called to the ministry of the North Parish church. A long, bitter salary dispute arose *c.* 1730, with many questioning his right to be paid while he was away in Ireland for six months. Some withheld their support, resulting in increased taxes that many property owners refused to pay and no one would collect. One faction sought his resignation, and the congregation split, with each side claiming the meetinghouse. Thereafter, he preached in his home, and his detractors employed their own minister. Despite being formally dismissed, Reverend Hillhouse retained possession of extensive lands that had been set aide for the support of the ministry, which only exacerbated the controversy. The resulting lawsuits are said to have hastened his death in 1740. Earlier, an anonymously authored defense had appeared in the form of a dialogue between "two honest Country-men," "Dick Justice" and "Tom Plain-dealing."

JOHN DOLBEARE OF BOSTON. Born *c.* 1669, this very wealthy pewterer and ironmonger purchased thousands of acres in the North Parish, which all passed to his son George in 1740. (New-York Historical Society.)

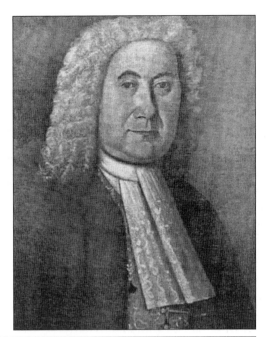

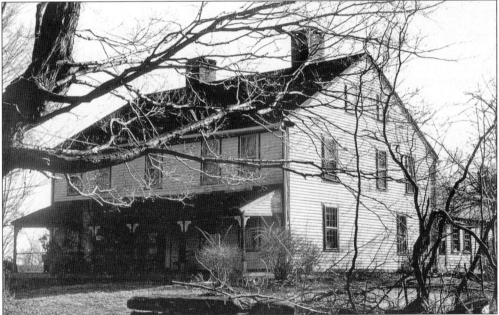

GEORGE DOLBEARE. George Dolbeare was born *c.* 1715. Lorenzo Dow wrote that Dolbeare "was considered a great man in his day, having four saw mills" and several farms containing thousands of acres. His very large house on Dolbeare Hill was built in 1749, and it originally had a third story within a gambrel roof. Probably after being damaged in the great gale of 1815, it was reduced to its present size. Dolbeare died in 1772, leaving a large estate that included several slaves. He does not frequently appear in the annals of the North Parish. "Hearing decrees of Predestination preached, he concluded that it was of little account for us to go to meeting, if all our destinies were fixed, and hence made himself scarce from the pew," explained Dow. In the early 20th century, this home was a summer boardinghouse featuring 20 guest rooms.

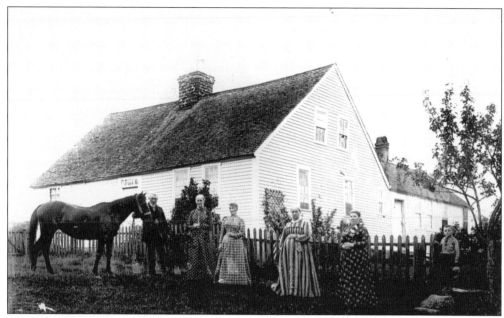

THE REV. ROZEL COOK FARM. Rozel Cook was called by the North Parish church in 1784 to be its third pastor. The parish paid for the purchase of a farm from the heirs of Peletiah Bliss and provided Reverend Cook with 60 pounds in salary and 30 cords of wood annually. At some time in the late 19th century the old house disappeared, and a new one was built in the same place on Simpson's Lane. Samuel Rogers had settled *c.* 1670 on the plain nearby. (Montville Historical Society.)

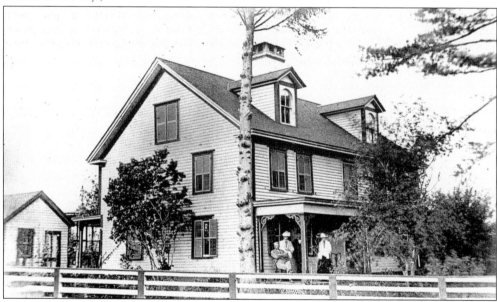

THE NATHAN SMITH HOUSE, LATER THE RESIDENCE OF HON. FRANCIS FELLOWES. Nathan Smith came from Lyme *c.* 1760. He was a tanner and is said to have had 14 children. Built into a knoll, his house was constructed in several stages. Years later, Hartford attorney Francis Fellowes had the old Smith house remodeled and used it as a summer home until his death in 1888. It stands on Fellowes Road. (Connecticut Historical Society Museum, Hartford.)

Two

THE EARLY TOWN

Eleven new Connecticut towns were established in 1786, including Montville, and the Revolution-era spirit of independence must have been an element of that trend. In the former North Parish, optimism that local control of taxation and expenditure would serve the collective self-interest may have been another factor. The new town of Montville was on its own.

Montville's early years were an era of democratization. Farms became smaller as estates diminished through inheritance, unlike the old English system of primogeniture. Civil and religious authority became separate matters, and democratic ideals were even reflected in architecture. Ultimately a public library appeared. Montville remained a quiet rural community, even as gristmills and sawmills were giving way to manufacturing enterprises. The town was home to the statesman, the storekeeper, and the stockman profiled in these pages, as well as to a singularly eccentric character.

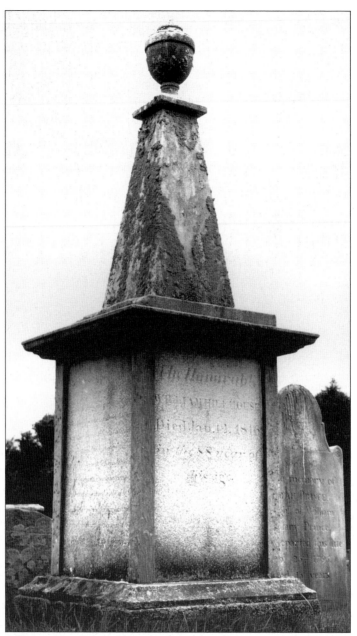

JUDGE WILLIAM HILLHOUSE. The elder surviving son of Rev. James Hillhouse and a judge of the county and probate courts, William Hillhouse (1728–1816) was elected to the legislature at age 27, served 30 years, and was then appointed to the council (a precursor to the state senate). He served until 1808, traveling upon his Narragansett Pacer since he "abhorred wheeled carriages." Not many years after his death, he was described by grandson James A. Hillhouse as "a tall, spare man . . . the oldest Counsellor—at the Governor's right hand sat, ever, the Patriarch of Montville." The town of Montville was incorporated by an act of the General Assembly in 1786. Whether it was the subtle auto-epitaph of "the Patriarch of Montville" himself, or perhaps his father's vicarious final word, "Montville . . . is a covert reference to the Hillhouse family name," wrote historian Franklin Bowditch Dexter in 1885.

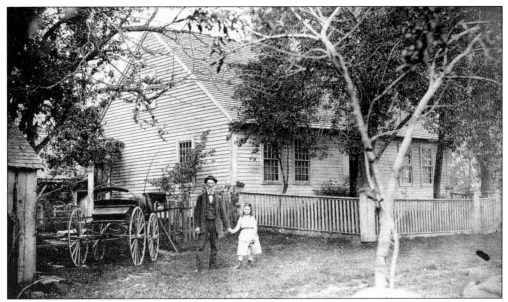

OLIVER BAKER'S HOUSE. Oliver Baker built this house in 1803, according to his son, historian Henry A. Baker, who is seen here. The house stood on Simpson's Lane. Oliver Baker and several members of his family were interred nearby in the Old Rogers Burying Ground, located along (and perhaps partially beneath) the modern Pires Drive. In 1896, Henry Baker described nearly 100 graves, including that of Samuel Rogers, who settled on the Mohegan lands *c*. 1670 and died in 1713. Most of the graves are now desecrated.

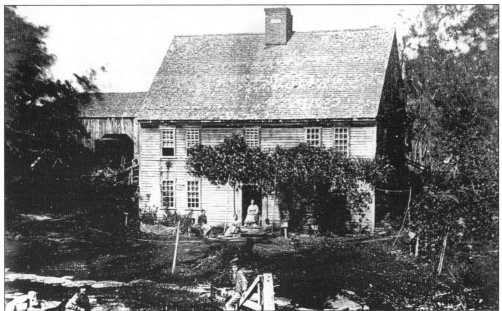

THE ELISHA ROGERS HOUSE. Set picturesquely into a hillside, this house was built by Capt. Thomas Rogers in 1789 on land bought from the Mohegans two years earlier. It stood on Fitch Hill Road at what is now the northern driveway of the Jacobowitz trailer park. Thomas Rogers, as captain of a merchant vessel, made 40 voyages to the West Indies. His grandson Elisha, a carpenter, later lived here. (Connecticut Historical Society Museum, Hartford.)

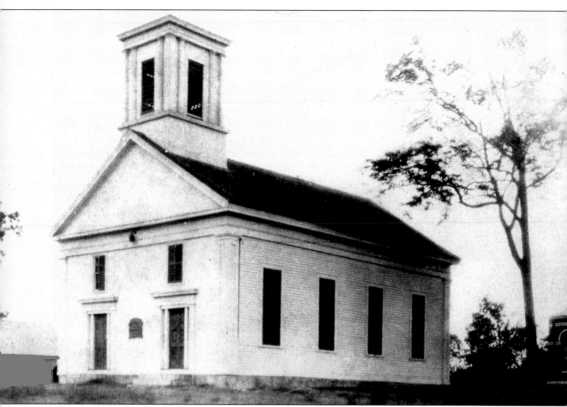

THE NEW ENGLAND RELIGION. The present Montville Center Congregational Church was built in 1847, a successor to the first meetinghouse built in 1723 within the present Raymond Hill Cemetery. In 1739, Rev. David Jewett, a trusted missionary among the Mohegan, became its second pastor. Subsequently, quite a number of the Mohegans joined the church, and there was interest in rebuilding it farther east for their easier access. According to its records, the North Parish finally voted in 1772 to "build a new meeting-house at the northeast corner of the meadow of Joshua Raymond, at a place known by the name of the White Oak Stub." During worship on May 25, 1823, lightning struck the spire of the 1772 meetinghouse, killing two and injuring others. Within months, 66 people professed their faith and joined the church.

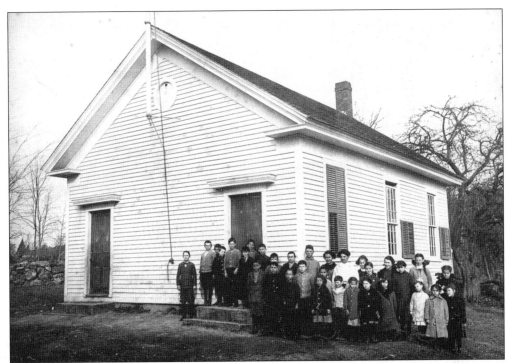

MONTVILLE CENTER SCHOOL. A new schoolhouse was built in Montville Center around the same time as the 1847 Congregational church, which it complimented architecturally. This photograph shows the students of 1913–1914. This former one-room school still stands, quite recognizable after having been converted to a home years ago. (Montville Historical Society.)

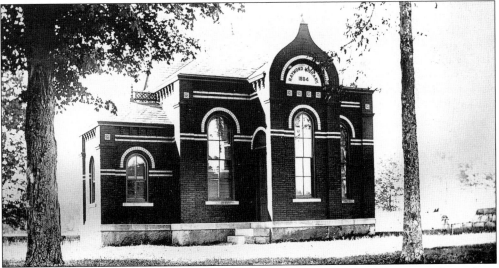

RAYMOND LIBRARY. As long ago as 1823, there was a library at Montville Center. It was kept in the old store that once existed there and was for the private use of subscribers. In 1880, the Raymond Library Company was established pursuant to the will of Albert C. Raymond, who left $10,000 in trust for a public library. A Romanesque-style building was constructed in 1884–1885 and remains in use, albeit with modern alterations that somewhat overwhelm the original architecture. (Montville Historical Society.)

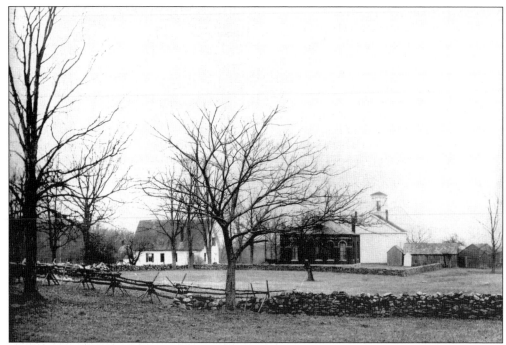

MONTVILLE CENTER, SEEN FROM THE SOUTHWEST. With walls and fences reminiscent of a Mathew Brady photograph, this tranquil *c.* 1900 image seems timeless, but in fact many changes had occurred not long before it was taken. At the left, the chapel replaced an ancient store in 1884, and the Raymond Library was also fairly new. The Congregational church is seen surrounded by its now long-gone horse sheds, and a small building to the right of the library is identified as the "hearse house." (Montville Historical Society.)

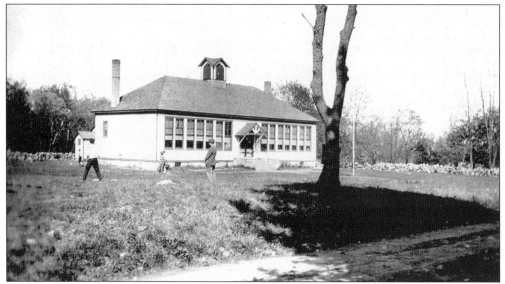

THE MONTVILLE CENTER TWO-ROOM SCHOOL. A new school was opened at Montville Center in 1920 to better serve the needs of the First School District. It contained two classrooms. The district was consolidated with four other rural districts when Fair Oaks School opened in 1948, and this building was subsequently demolished. Two houses now stand on the site.

NATHANIEL PARISH (1777–1868).
A 1905 biographical sketch states that Parish "came to Montville a poor boy. He had but limited educational advantages, and had been obliged to take early upon his shoulders the responsibility for his own support. For many years he conducted a general store near the Montville Center Congregational Church, in which line he met with gratifying success. … He was a careful business man, and gave personal attention to his varied interests. The present chapel of the Montville Congregational Church stands on the site of the old Parish store. In politics Mr. Parish was an old-line Whig."

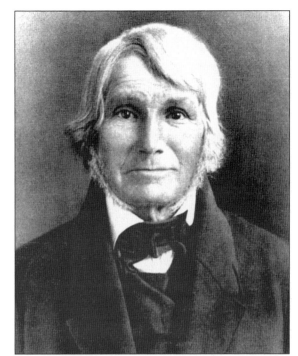

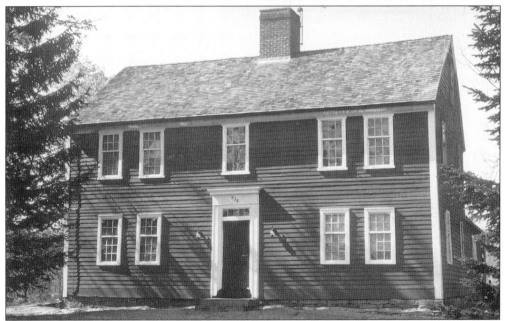

THE JOSIAH RAYMOND HOUSE, BUILT C. 1795. Several great-grandsons of Mercy Sands Raymond received farms that formerly comprised her "Great Farm" on Raymond Hill. One great-grandson, Josiah Raymond, died while building this house in 1795. "His death was caused by a bruise received upon one of his feet," according to historian Henry A. Baker. The home was purchased by farmer and merchant Nathaniel Parish c. 1830. This early house has been neglected for years, and its future appears bleak at the time of this writing. In an era of houses arriving on trucks, a craftsman-built dwelling that stands into its third century is a rarity.

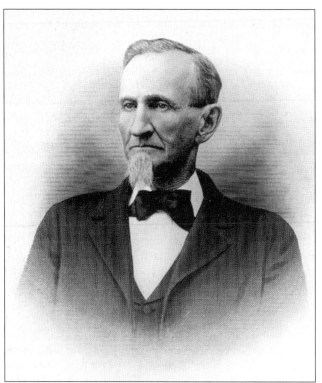

JAMES H. MANWARING.
James Hillhouse Manwaring was born in 1827 on the Manwaring homestead, which contained about 500 acres overlooking Oxoboxo Lake. A horse and cattle dealer, he was, according to his obituary, "the first to introduce Western cattle into New London County for slaughtering," bringing in large droves at a time. The largest landowner in town in his day, Manwaring died in 1914.

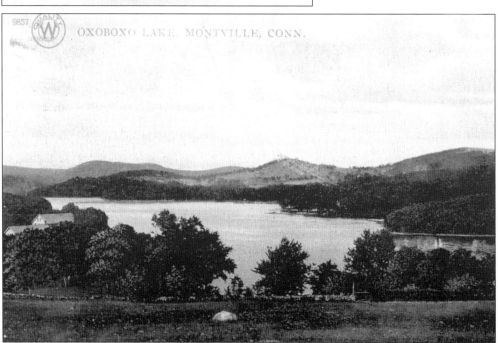

OXOBOXO LAKE, C. 1910. This view from the north shows that the reforestation of abandoned pastures has had as profound an aesthetic impact as did the clearing of the land in the first place. Looking down from part of the old Manwaring homestead, the view included Dolbeare, Chapel, and Chapman Hills. (Charles Dennis.)

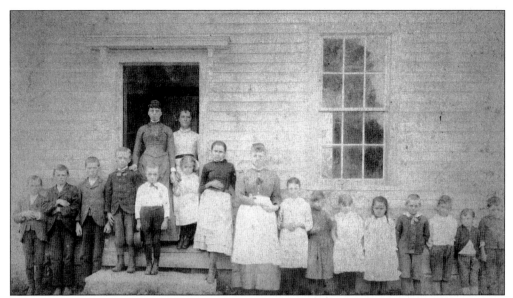

MANWARING SCHOOL, LATE 1880S. Located near the westerly side of Raymond Hill, this rural school took the name of the adjacent landowner. The names of the teacher and "pupil teacher" in the doorway are not known. The children are, from left to right, James Lathrop, Theodore Lehman, Patsy Lucy, Prentice Williams, Austin Avery, Edith Williams, Belle Austin (who would later marry James Lathrop), Jennie Williams, Stella Avery, Birdy Randall, Lottie Lathrop, Alice Austin, Henry Williams, Charlie Randall, George Randall, and Charlie Lehman. Closed in 1948, the old school was moved slightly and then extensively remodeled into the home at 1486 Route 163. (Raymond Library.)

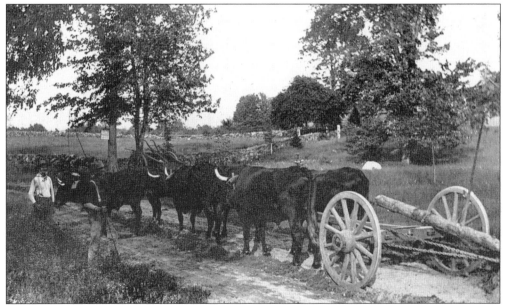

ROAD REPAIRS, C. 1910. In this Montville scene, probably along the Old Colchester Road, three pairs of oxen pull a fairly rough-and-ready grading rig consisting of a scraper chained to a log that is dragged behind a pair of wheels. Extreme economy in equipment purchases is evidently nothing new. (Carol Kimball.)

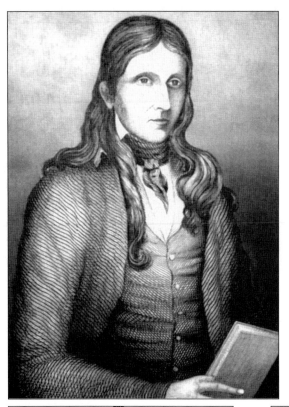

LORENZO DOW. Lorenzo Dow came to live in Montville *c.* 1822. Born in 1777, he "was one of the most conspicuous characters in America at the beginning of the 19th century," reflected historian Henry A. Baker in 1896. An itinerant Methodist, Dow was part preacher and part entertainment, a people's philosopher and one of the first self-promoted celebrities. Touring all around the nation, the awe-inspiring but eccentric Dow would preach wherever he went, announcing future visits months in advance, and return precisely on schedule. His outspokenness and impassioned methods only furthered the fame of "Crazy Dow," and his books sold many editions. Dow believed in free salvation, and he railed constantly against the Calvinist predestination that characterized conventional New England religion. His now-colloquial definition of Calvinism was "You will be damned if you do. And you will be damned if you don't."

THE

DEALINGS OF

GOD, MAN, AND THE DEVIL;

AS EXEMPLIFIED IN THE

LIFE, EXPERIENCE, AND TRAVELS

OF

LORENZO DOW,

IN A PERIOD OF OVER HALF A CENTURY:

TOGETHER WITH HIS

POLEMIC AND MISCELLANEOUS WRITINGS,

COMPLETE.

TO WHICH IS ADDED

THE VICISSITUDES OF LIFE,

BY PEGGY DOW.

Many shall run to and fro, and knowledge shall be increased.—*David.*

NEW YORK:

SHELDON, LAMPORT & BLAKEMAN,

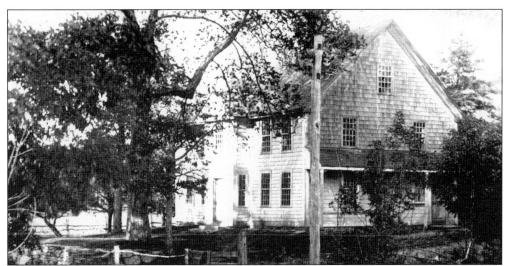

THE LORENZO DOW PLACE. Death deprived Lorenzo Dow of his loyal helpmate Peggy in 1820, and he found himself wanting a new wife. While preaching at Bean Hill one day, he met and proposed marriage to Lucy Dolbeare, who inherited this house and the farm that once surrounded it on the Old Colchester Road. One story has it that he asked for a volunteer. But he found Lucy to be a stern and demanding wife, and on his front gate he once painted "Women Rule Here." Dow was an enthusiastic Jackson supporter: when "Old Hickory" and Van Buren were passing nearby en route to Norwich in 1833, Dow had the flag flying on a tall hickory pole at the Bland Tavern just up the road at the present Routes 82 and 354, where he assembled a large crowd. Lorenzo Dow died in 1834.

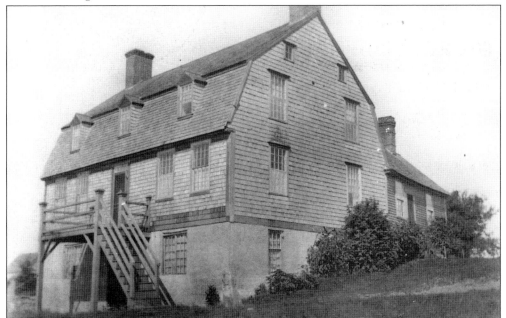

BLAND TAVERN. Southwestern Salem was part of Montville until 1819. Just over the present line stands the Bland Tavern, also known as the Halfway House due to its position along the Norwich and Essex Turnpike. This was the scene of Lorenzo Dow's great salutation of Andrew Jackson, who gave a speech from the porch.

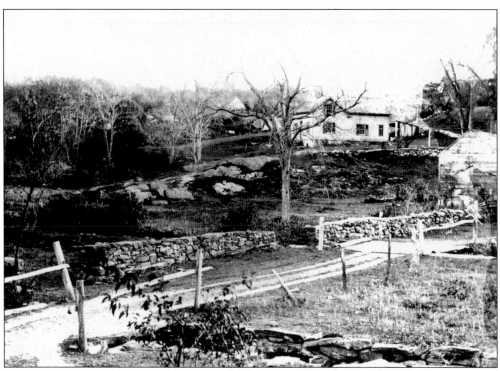

NEAR THE OXOBOXO DAM. Lorenzo Dow owned a sawmill and gristmill here. In a celebrated episode, he rebuilt the dam in 1826 and raised it several feet higher, reasoning that greater capacity would benefit him as well as other mill owners downstream. A great lawsuit ensued, in which the owners of the Uncasville Mill claimed a prescriptive right to unrestrained flow, and a jury found Dow liable and assessed damages. He paid, but immediately opened his dam and let the water flow out as fast as it would, causing a good deal of damage below. Dow, who had previous experience with the law, was never one to miss an opportunity. He milked the whole episode into "Wisdom Displayed, and Lorenzo's Villainy Detected, or The Second Trial, Confession and Condemnation of Lorenzo Dow," an irony-laced diatribe that he included in many editions of his popular books. (Montville Historical Society.)

WISDOM DISPLAYED, AND LORENZO'S VIL LAINY DETECTED

OR THE SECOND TRIAL, CONFESSION AND CONDEMNATION OF LORENZO DOW,

Before the Superior Court, held at Norwich, Conn. January Term, 1829.

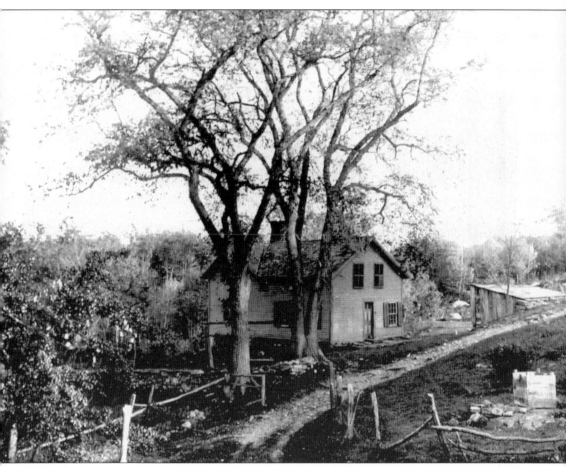

A House near the Oxoboxo Dam. Early spellings such as "Obsopogsant" and "Oxopaugsuck" suggest the true native pronunciation of what the early colonists more often called the "Little Pond," the present lake being only partly man-made. Lorenzo Dow deserves credit for disseminating in his writings something like the true native name in the then-fashionable form of a palindrome, and "Oxoboxo" it remains. This is a closer view of the rather idyllic house that appears in the previous image. In the years before the Civil War it belonged to G. R. Lewis & Company, who purchased the Uncasville Mill from its litigious original owners, raised the Oxoboxo Dam higher, and for a time operated a cotton mill here as well. (Montville Historical Society.)

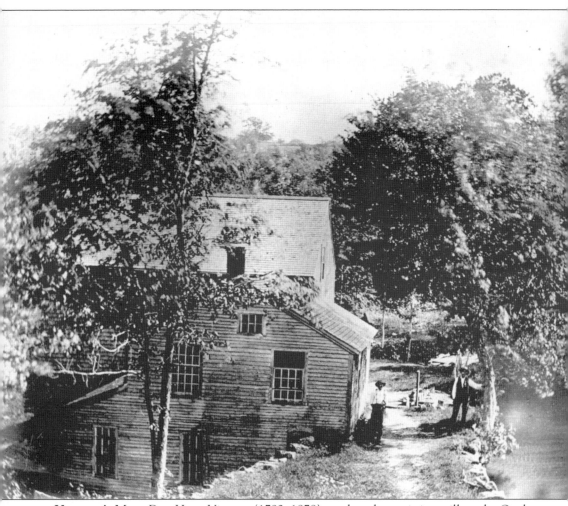

VINCENT'S MILL. Dea. Harry Vincent (1792–1878) purchased an existing mill on the Oxoboxo Brook in 1829 and enlarged it, putting in carding and spinning machinery. Vincent produced flannel and cassimere, a twilled woolen fabric. Henry A. Baker wrote of him in 1882 that "so great was his trust in the Divine Providence that he was strenuously opposed" to any insurance against loss, "and was never known to have suffered any." After Vincent's death, Raymond N. Parish built an up-to-date sawmill, seen here behind the older woolen establishment. These mills stood just south of the present Williams Road. (Copyright Mystic Seaport, Everett A. Scholfield Collection, Mystic, Connecticut.)

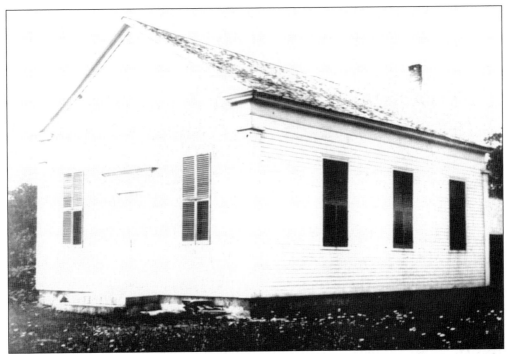

GARDNER LAKE METHODIST CHURCH. The area along the old Norwich and Essex Turnpike near northwestern Montville's other lake was known in the 19th century as Gardnertown. This was its Methodist church; its architecture is typical of the early 19th century. After falling into disuse, the little church was purchased by the controversial Ed Doyle in 1947, fitted out as "St. Edward's Chapel," and presented to Roman Catholic authorities for summertime Masses. It is now a residence on Route 82 at Church Lane. (Montville Historical Society.)

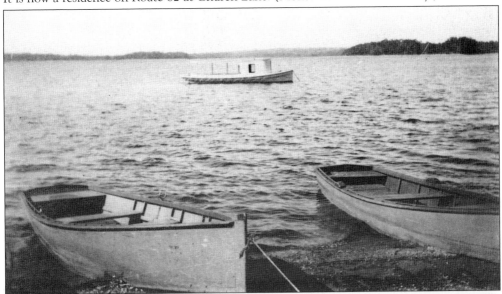

BOATS AT GARDNER LAKE. Referred to in some early records as "Oplinsk" but once more commonly known as "Twenty-mile Pond," the lake was to become increasingly popular when automobiles appeared on the scene. (Charles Dennis.)

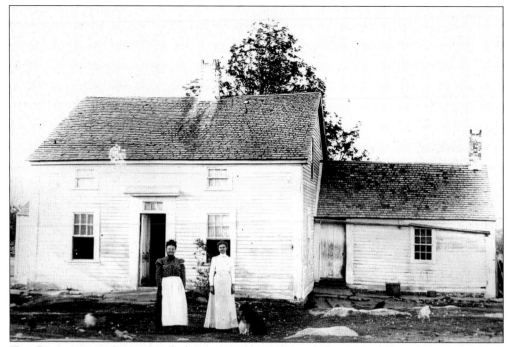

THE DORCHESTER PLACE. Asahel Otis (1768–1837) "settled at Montville, a farmer, and lived on the farm which he afterwards gave to his daughter, Mary Dorchester, since called the Dorchester Place," according to Henry A. Baker. In 1881, John Glasbrenner, a native of the German state of Würtemberg who had arrived in America in 1855, purchased the 300-acre farm with savings from his 15 years of work in a Norwich mill. Seen here *c.* 1900, the old house burned to the ground in the 1930s. It stood on Forsyth Road, about opposite the Chapel Hill road. Like many old Montville farms, this land has now been consumed by developers, although the Otis family cemetery may still be seen.

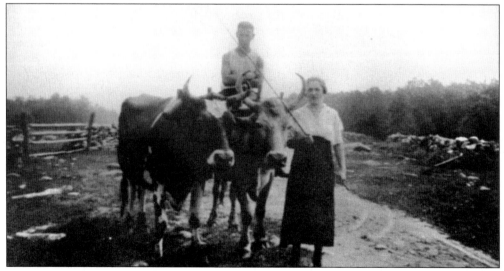

FORSYTH ROAD, c. 1920. Along the road near the old Dorchester place, neighbors drive cattle in a scene that could not be further removed from the intensive development of the area in recent years.

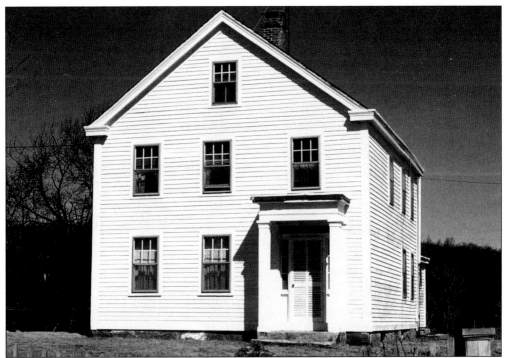

A GREEK REVIVAL HOUSE. When David R. Dolbeare built his house near Montville Center c. 1840, Jacksonian democracy was still accompanied by a more Jeffersonian taste for the architecture of Greece and Rome. Pictured about 25 years ago, this building was once a pristine example. Today, all of the old work has been stripped away, even the Doric-columned porch. At least someone managed to save the pieces.

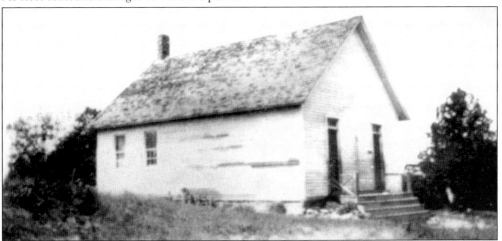

CHAPEL HILL SCHOOL. This one-room school stood on Chapel Hill at the north end of Fire Street. Chapel Hill, where many of the Chapel name once settled, is now frequently confused with the higher ground near the Oakdale Firehouse. Many even pronounce "Chapel Hill" strangely now, making it sound like the town in North Carolina. The *a* is properly long (chay-pel), a distinction Frances Manwaring Caulkins made in her 1860 *History of New London*. When Ed Chapel of Oregon recently visited his ancestral hill, it was pleasing to note that he pronounces his name correctly. (Montville Board of Education.)

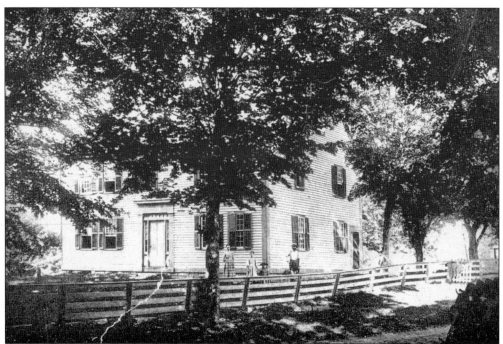

THE DANIEL F. RAYMOND HOUSE. Born *c.* 1755, Daniel Fitch Raymond owned a farm that is now Camp Oakdale. It had once been part of the ancestral Raymond "Great Farm" that encompassed several thousand acres. By the turn of the 20th century, this property belonged to Abraham Lifshitz, whose family later developed it as a summer resort. Later still, the town bought the property. A prominent feature of this Colonial house was its front entrance in the Greek Revival style, an early 19th century modernization. The old house burned down *c.* 1970, but a large dining hall addition at the rear was retained for a number of years as a community center. Other buildings were gradually removed. With all of that well in the future, Cora Hanney, Ethel Church, Lila Chapman, and Moses Chapman pose here in the 1890s. Oxoboxo Dam Road runs along the fence.

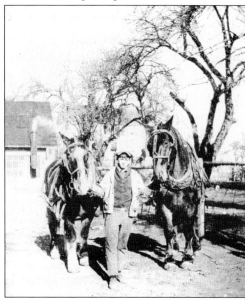

ON THE FITCH HILL FARM, C. 1910. This scene was repeated daily on countless Montville farms. (Helen Coggeshall)

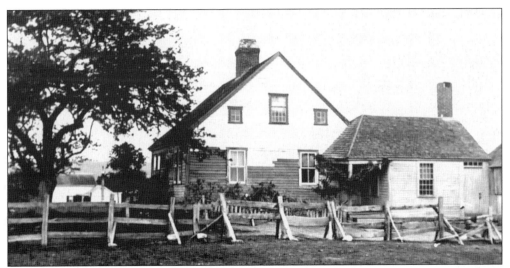

THE JOSIAH BAKER HOUSE. In 1797, Josiah Baker, formerly of Chesterfield, built this house on land left to him in 1771. It still stands on Raymond Hill Road, a short distance southeast of Gutterman Road. Seen here in the late 19th century, it appears to have just undergone repairs. Josiah Baker's great-grandfather received a deed to a very large tract of the surrounding land from Uncas's son Oweneco, who died in 1715. Oweneco's weakness for alcohol was often taken advantage of (and satisfied) by colonists greedy for more and more of the Mohegan lands. (Montville Historical Society.)

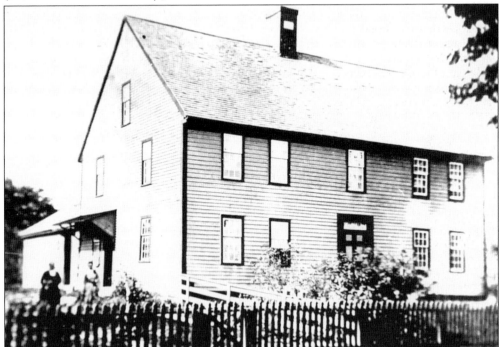

THE JONATHAN HILL HOUSE ON LYNCH HILL ROAD. John Vibber was living on this tract in 1711, but in 1741 he and George Hill exchanged farms. Hill's son Jonathan built a new house on the place in 1787; it is seen here c. 1890. It disappeared during the 20th century, although the old barns still stand opposite the present house. (Montville Historical Society.)

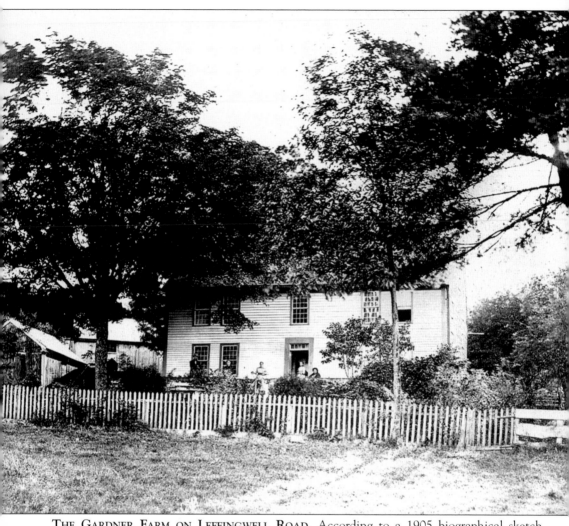

THE GARDNER FARM ON LEFFINGWELL ROAD. According to a 1905 biographical sketch, John Fitch Gardner "was born on the turnpike, near Trading Cove" in 1808 and in 1839 fell heir to one of the Fitch farms along Trading Cove Brook. A son, Henry Gardner, was born in 1832 and married Carolyn (Beebe) Shaw, and they are seen here with their family in front of their neatly kept old home. Today it is nothing but garbage-strewn, overgrown cellars on the hillside opposite Montville Road. The expansive fields it once overlooked are now desolate gravel pits behind the Norwich Wal-Mart. An excerpt from Edwin Arlington Robinson's poem entitled "The House on the Hill" reflects the fate of this and so many other historic homesteads in Montville: "There is ruin and decay / In the House on the Hill: / They are all gone away, / There is nothing more to say." (Charlotte Allen)

Three

INDUSTRY AND GROWTH

With a total fall of the Oxoboxo of nearly 400 feet to the Thames River, Montville was ideally positioned to be a participant in the early industrial age. The English industrial revolution was still echoing when John and Arthur Scholfield combined abundant waterpower, local availability of wool, and their own ingenuity. The paper industry that developed somewhat later remains a living connection with 19th-century Montville, albeit a now diminished link, but the members of the Palmer family deserve the most credit for shaping a modern town.

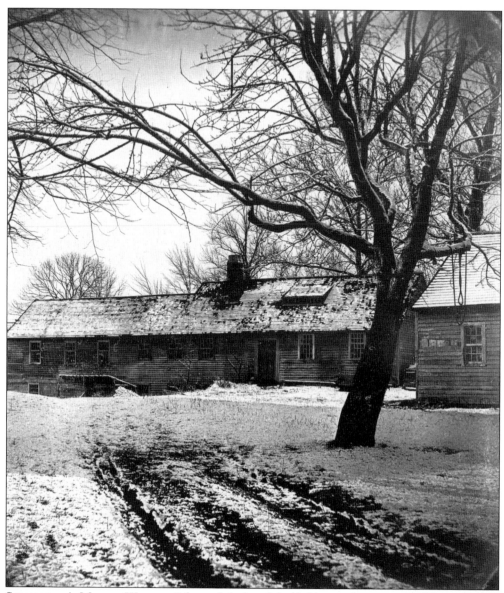

SCHOLFIELD'S MILL IN WINTER. John and Arthur Scholfield were the pioneers of the American woolen industry. Emigrating from Yorkshire in 1793, they first settled in Massachusetts and built from memory the first successful carding machine in this country. By 1798, they had leased a mill site near the mouth of the Oxoboxo, where they were the first to produce woolen cloth by waterpower in Connecticut. In 1814, John Scholfield purchased an existing mill at what has since been known as Scholfield's Pond and expanded and equipped it for woolen cloth production. (Copyright Mystic Seaport, Everett A. Scholfield Collection, Mystic, Connecticut.)

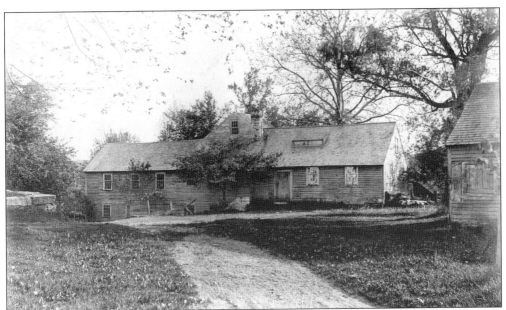

SCHOLFIELD'S CELEBRATED SATINET. For almost a century, woolens were produced here, including "Scholfield's Celebrated Satinet," a fabric consisting of cotton warp and woolen weft. Comparing this photograph to the one on the opposite page, it is remarkable that even in the latter part of the 19th century, the building continued to grow. A central gable has appeared, no doubt reflecting changes in the machinery within, although the wool house at right has deteriorated a bit more. (Copyright Mystic Seaport, Everett A. Scholfield Collection, Mystic, Connecticut.)

THE WOOL HOUSE AT SCHOLFIELD'S MILL. This early postcard depicts the millpond dam at the left, and at the right is a long-gone structure where wool evidently was stored. Old postcard images of Scholfield's Mill and its surroundings are not unusual; it seems that interest in Montville's historic sites was more common a century ago than it is today.

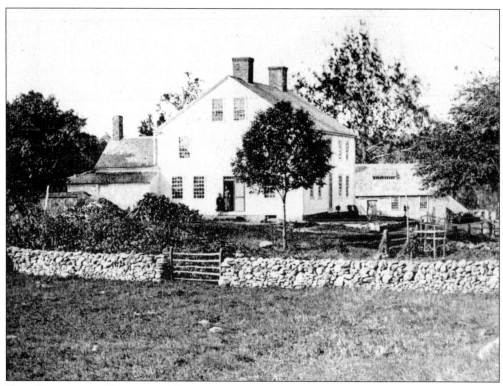

THE SCHOLFIELD HOUSE AND MILL, SEEN FROM THE EAST. This photograph, taken from approximately the site where the former Camp Oakdale Community Center later stood, shows the large residence, built *c.* 1814, and the mill beyond. (Montville Historical Society.)

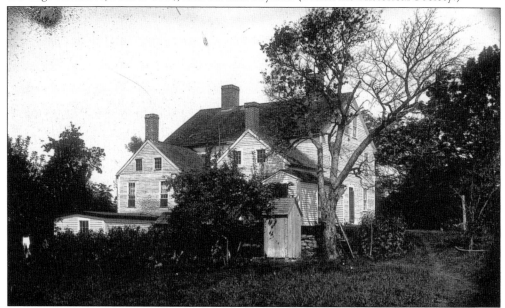

THE SCHOLFIELD HOUSE, SEEN FROM THE REAR. The paired kitchen ells reflect the several households this dwelling accommodated. There even appears to be a second outhouse, its roof barely visible below the second window from the left. (Montville Historical Society.)

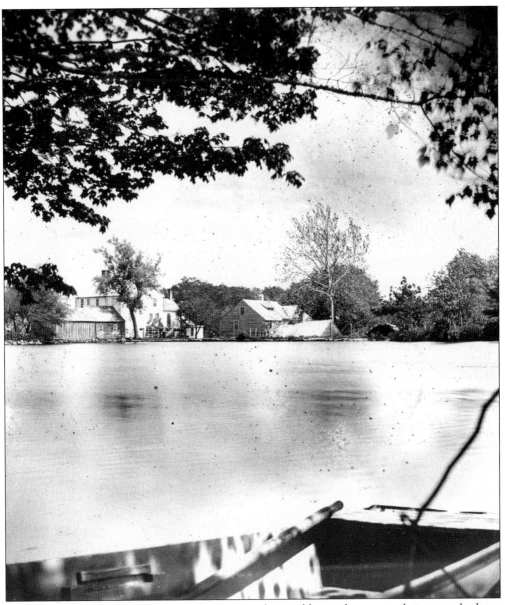

SCHOLFIELD'S POND. From left to right are seen the wool house for raw stock storage, the large mill residence, and the mill itself. (Copyright Mystic Seaport, Everett A. Scholfield Collection, Mystic, Connecticut.)

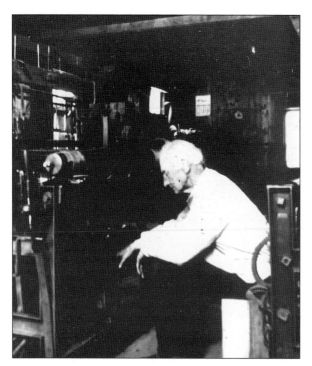

CHARLES F. SCHOLFIELD AT HIS MACHINERY. Charles Fox Scholfield saw the rise and fall of Montville's woolen industry. Born in 1817, by age 26 he was in partnership with his brother Joseph, manufacturing sateen and satinets in their grandfather's old mill at Scholfield's Pond. He later bought land and water rights just downstream and, in 1868, built a new mill. Producing flannels and kerseymeres (heavily felted woolens) until *c.* 1900, he abandoned the industry when he could no longer compete with larger mills. He died at the age of 95, at the very moment he finished putting his signature on a deed conveying much of his land and water rights to the Massasoit Company, cotton products manufacturers at the nearby Oakdale Mill. (Montville Historical Society.)

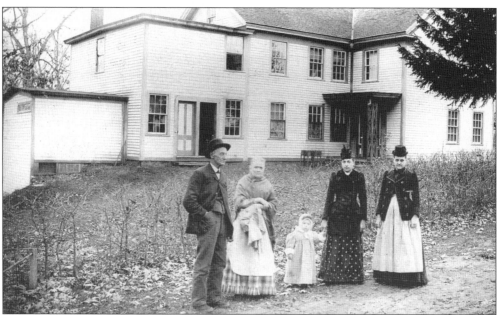

BROOKSIDE, THE RESIDENCE OF CHARLES F. SCHOLFIELD. At about the same time that he built his new mill in 1868, Charles F. Scholfield built a large residence in front of it. The mill is long gone, but this house still stands at 835 Route 163. Charles Scholfield stands in front of it here with wife Phebe (Winchester) and others. The utilitarian, flat-roofed additions at the left were probably associated with the woolen business. Scholfield's obituary describes a public-spirited man who in 1869 gave the land for a convenient new road between the Oakdale Mill and Fellows Road, now part of Route 163.

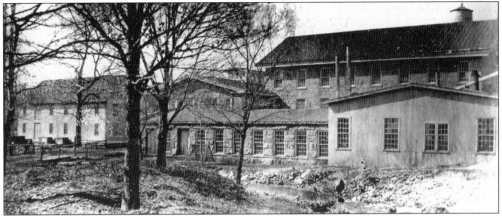

OAKDALE MILL. In 1866, James Bingham built the central portion of Oakdale Mill; its pleasant name was derived from the sparsely populated area then known as Fair Oaks. His paper mill employed two dams and a long ditch to direct the waters of both the Fox and Oxoboxo Brooks through its basement to power the machinery. In this view from the north, Meetinghouse Lane crosses the Oxoboxo before continuing south between a later wing of the stone mill complex and one of several wooden stockhouses. The curve of the road, the brook, and the location of the bridge are the same today, but everything else seen here is gone. (Carol Kimball.)

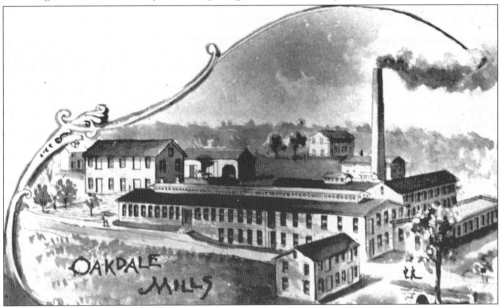

FROM PAPER TO COTTON. Bingham's paper mill was not in business very long. By 1880, the bank foreclosed and sold it to quilt manufacturers Palmer Brothers, who greatly expanded it and used it in connection with their factories at Palmertown and elsewhere. In this 1893 engraving, abundant smoke proclaims prosperity but also demonstrates that waterpower alone was no longer adequate and a steam engine had been added. That same year, the mill passed to the Massasoit Company of Fall River, of which the Palmer brothers were directors. Equipped as a bleachery and used to produce cotton wick and other "white" goods, the mill was later sold to L. W. Greiner and used to make cotton products during World War II. It was then sold to the Lanatin Corporation, but it fell into disuse. Gradual demolition commenced in the late 1970s. Only the small barn at the extreme left (located behind Yanni's Pizza) and the house at the rear center remain.

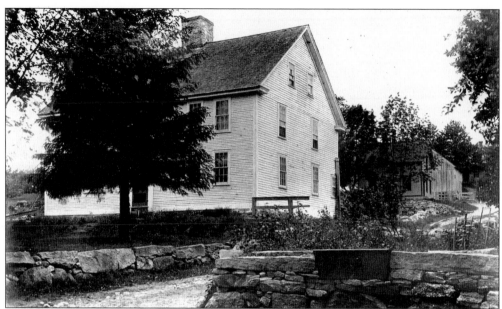

THE OLD ELDER PALMER HOUSE. Reuben Palmer (1759–1822) was a Baptist minister from Stonington. A Baptist church was formed in Montville in 1788 from the remnants of an earlier Separatist congregation, and Elder Palmer was called to be its pastor. The church stood near the Old Colchester Road, and its cemetery may still be seen, including Ruben Palmer's grave (pictured below). Besides being a successful minister (several hundred people were baptized during his ministry), Elder Palmer was also an enterprising manufacturer who set in motion the development of Palmertown by several generations of his progeny. From 1798, he operated an oil mill, extracting linseed oil from the flax plant. The residual "oil-cakes" were sold as animal fodder. The Palmer Memorial School was built, twice, on the site of Elder Palmer's house. (Connecticut Historical Society Museum, Hartford.)

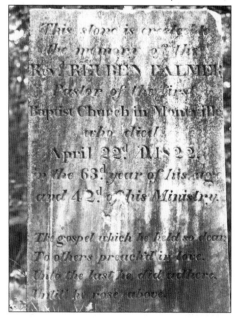

THE UNION BAPTIST CHURCH. Over the years, membership in the Elder Palmer church diminished, but a revival in the winter of 1841–1842 led to the organization of the Union Baptist Church. A new building was built on Maple Avenue, but in 1867 the much larger church seen here was erected on the present Route 163 site. It burned in 1930. The present brick structure was dedicated in 1933. (Right: Charles Dennis. Below: Carol Kimball.)

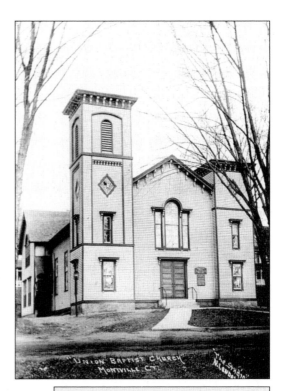

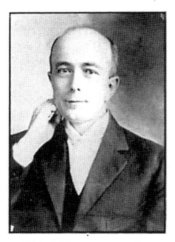

You Are Cordially Invited

TO THE

Union Baptist Church

MONTVILLE - CONN.

Rev. George C. Chappell

PASTOR

SUNDAY SERVICES

Preaching - - - 10.45 a. m.

Weekly Offering

Bible School - - - 12 o'clock

Communion—Third Sunday in each month.

Pleasant Sunday Evening Hour
6.30 to 7.30 p. m.

Inspiring Song Service, Orchestra Leading

Attractive Young People's Program, with special musical features

Gospel Sermon by the Pastor

Thursday Evening Prayer Meeting
at 7.30

We will give you the Glad Hand

47

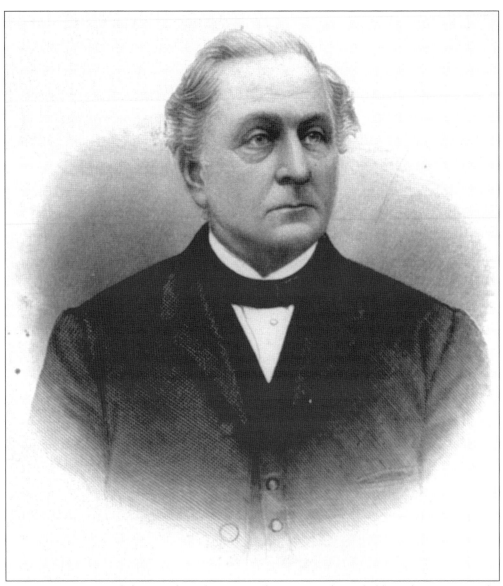

ELISHA H. PALMER. Elisha H. Palmer (1814–1895) was a grandson of Elder Palmer. In 1850, he purchased the old Palmer linseed oil mill from his father, Gideon (who had perhaps seen the handwriting on the wall in the textile industry), and developed a process for extracting cottonseed oil instead. Elisha H. Palmer continued in that business, and he also manufactured cotton rope, twine, and batting. Noted to be a fervent supporter of the causes of temperance and abolitionism, in 1866 he erected the central portion of the familiar stone mill at Palmertown.

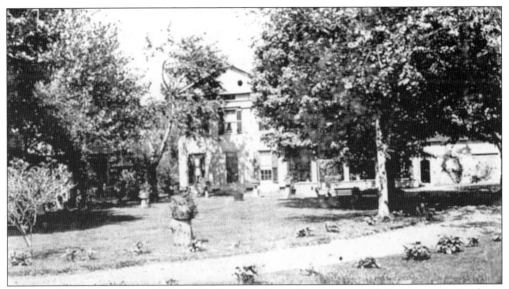

THE PALMER HOMESTEAD. Elisha H. Palmer lived amid extensive, well-kept grounds in a large residence just across the road from the venerable Elder Palmer house. Years after his death, the town purchased the homestead in 1946 as an annex to the Palmer Memorial School. Later, the American Legion hall was built on the site, while the grounds became the public works garage. Elisha H. Palmer's elaborate gardens and his ardent support of temperance were both seemingly long forgotten. (Connecticut Historical Society Museum, Hartford.)

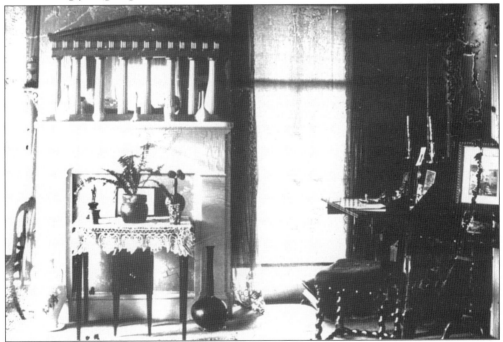

THE INTERIOR OF THE PALMER HOMESTEAD, C. 1890. The furnishings suggest refinement and taste. The unusual mirror, in the form of the Parthenon, turns up again in mid 20th century published photographs of the 18th-century East Haddam home of architect Frédéric C. Palmer, a grandson of Elisha H. Palmer. (Montville Historical Society.)

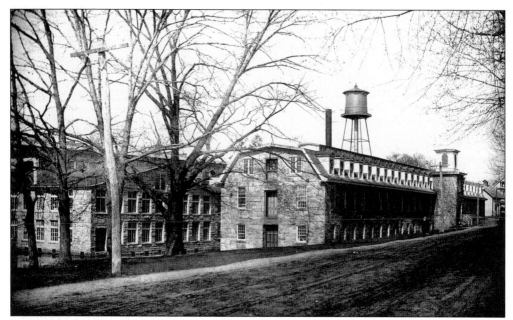

PALMER BROTHERS MILLS. The cotton batting produced by E. H. Palmer was destined for use as quilt filling. But *c.* 1875, a wholesale customer perceived a market and suggested that Palmer produce not merely the filling but finished quilts instead. His name was A. Montgomery Ward. The enterprising sons of Elisha Palmer formed a new business and recruited neighborhood women to assemble quilts in their homes. Soon they took over and expanded their father's mill. (Montville Historical Society.)

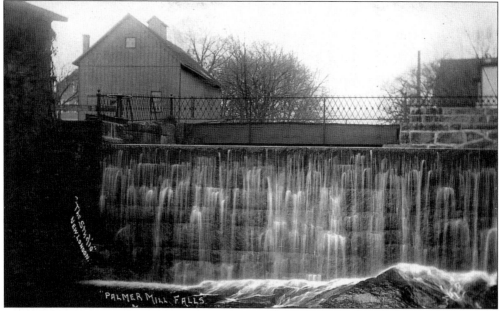

PALMER MILL FALLS. Bridge Street crosses the Oxoboxo above the dam, and at the left is a hand wheel for controlling the flow into one of the turbines within the mills. A fragment of the decorative iron railing remains today, having somehow survived the reconstruction of the bridge in recent years. (Charles Dennis.)

QUILTING MACHINES PATENTED BY THE PALMER BROTHERS.
The Palmers' cottage industry gave way to mechanization. Here, movable quilting frames with long sewing machine arms occupy the upper floor of the mill, which was extended in length several times; other buildings were later added. Palmer Brothers eventually had mills at Oakdale, Fitchville, and New London, and, at one time, 15 or more boxcars of Palmer quilts left the region daily. The product line ranged from fine-quality goose-down comforters to furniture-moving pads. Large quantities of cheap quilts were supplied to steamship lines for use by immigrants and were discarded after each passage. (Montville Historical Society.)

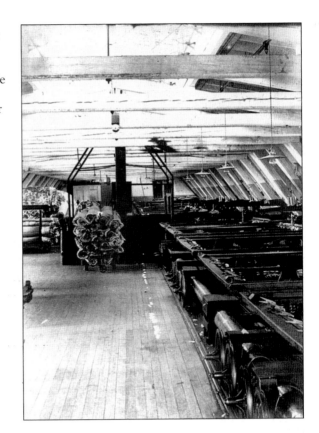

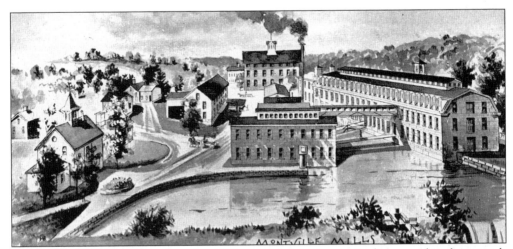

MONTVILLE MILLS. At the left in this 1893 engraving, an impressive barn stood in the grounds of Elisha H. Palmer's residence, which was just out of view. Water surrounds and reflects the mills, although this pond actually supplied another factory downstream. A big wooden stockhouse with an impressive cupola stands at the rear of the scene. Today, the Palmer barn and well-kept grounds have given way to the town garage, the pond has been drained, and the stockhouse has been demolished for its old timbers. The stone mills are still more or less intact.

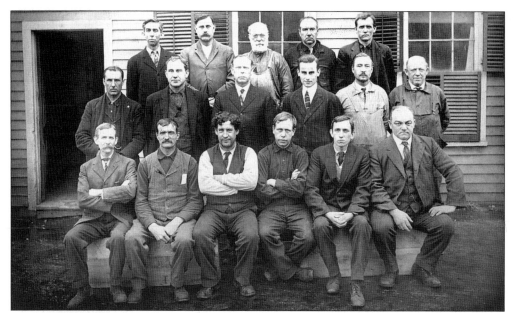

PALMER BROTHERS EMPLOYEES. This portrait was taken near the end of the 19th century. The caption written on the back reads "Palmer Bros. Co. Workers Foremen." Seen from left to right are the following: (first row) John Lynch, Joseph Cushion, Adam Rilchie, Bob Paton, Fred Crandall, and Norm Allen; (second row) Frank Gero, Ray Woodmansee, Edward Henry, Alfred Melcer, Wallace Daniels, and Wm. Smiddy. Four of the five men in the back row are Fred Chapel, Mike Hickey, William Webster, and Melvin Furber, but it is unknown which man is which. (Montville Historical Society.)

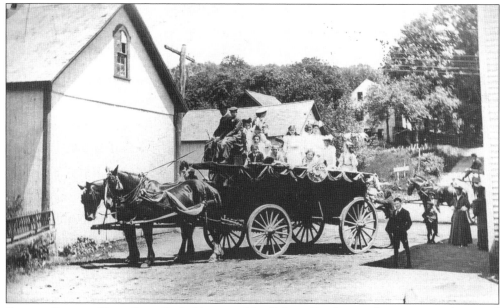

BRIDGE STREET, EAST END. Probably owned by Palmer Brothers, a heavy wagon festooned with colorful bunting has just turned into Bridge Street. Perhaps it was a pre-automobile rendition of the annual school outing seen elsewhere in these pages. Only the house on the hillside remains in 2004. (Montville Historical Society.)

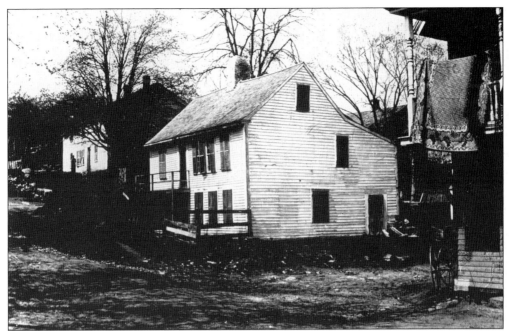

A HOUSE ON BRIDGE STREET, WEST END. The foundations of this house remained until recent road improvements were made. The store at the right has also vanished. On the far side of Palmertown's back road (Maple Avenue) stands the original Union Baptist Church of 1842, as remodeled for other purposes after 1867. It too is long gone. (Montville Historical Society.)

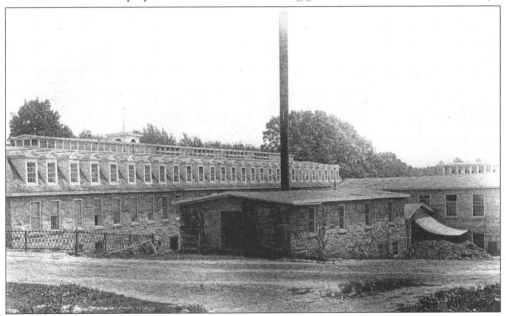

PALMER BROTHERS MILLS, SEEN FROM BRIDGE STREET. By the time this photograph was taken in 1896, the prosperous dormered quilt factory was tripled in length, and additional mills had been added in the rear on the west side of the Oxoboxo. Elder Reuben Palmer's 1798 oil mill formerly stood in the center foreground. After it burned down, it was replaced by this low-pitched stone building. (Connecticut Historical Society Museum, Hartford.)

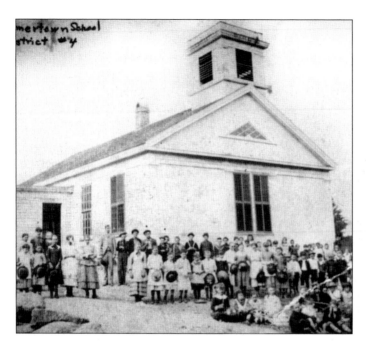

PALMERTOWN DISTRICT SCHOOL. The Fourth School District was in operation by 1840, and its attractive Greek Revival building appears typical of that time. The size of the student body seen here suggests that by the time this photograph was made late in the century, the building was far from adequate. (Montville Historical Society.)

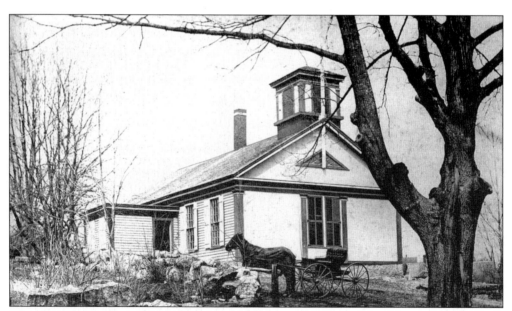

THE OLD TOWN HALL. After 1897, the old Palmertown District School became a town hall; it was not the last time the same process was to occur in Montville. A concrete records vault was added, all that remains of the building today. Contrary to popular belief, this was not the first town hall. A town house measuring 30 feet by 40 feet was built in 1848 on the Town Farm, at about the location of the Montville High School baseball infield, after the 1772 North Parish meetinghouse had been torn down to make way for the present Montville Center Congregational Church in 1847. (Montville Historical Society.)

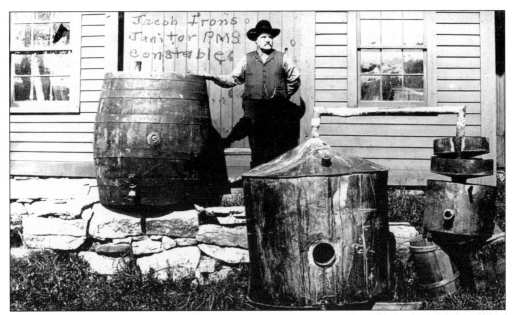

CONFISCATED? There is more than meets the eye here. Previously published as an example of Prohibition enforcement in Montville, this uncancelled postcard bears postal characteristics of the period from 1908 to 1915. Connecticut did not ratify the 18th Amendment, although it took effect nationally in late 1919. Is Constable Irons's stern pose indicative of his intent should Montville go "dry?" Or has he himself "signed the pledge?" (Charles Dennis.)

THE TOWN CLERK'S OFFICE. The sign indicates that the town clerk's office was located in this nondescript structure, which stood opposite the Palmer Brothers Mills. Within the porch, a braided rug and rocking chair lend a rustic touch. (Montville Historical Society.)

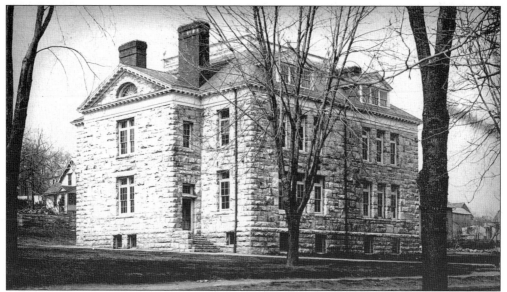

PALMER MEMORIAL SCHOOL. At the close of the 19th century, the Montville schools were outdated and overcrowded, particularly in Palmertown. An inexpensive new wooden school was planned, but instead four of the sons of Elisha H. Palmer gave the funds to build a substantial stone building as a memorial to their parents. It contained five classrooms, a public library with a librarian on the Palmer Brothers payroll, an auditorium and stage, and a third-floor meeting room for community fraternal lodges. The 1897 town account states that "the magnificent school building in District #4 is rapidly approaching completion." But it was not destined to last very long.

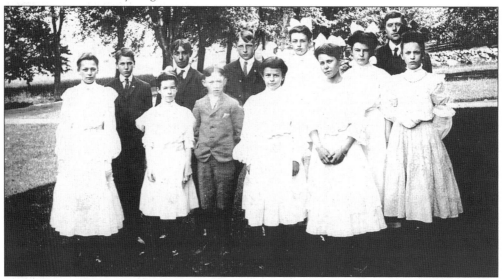

THE CLASS OF 1904. The eighth-grade graduates pictured here are, from left to right, the following: (front row) Georgabell Smith, Anna Quinn, Robert Walsh, Marion Manchester, and Ida Adams; (second row) Geo. Wood, Edward Adams, Jas. Phillips, Jeneva Smith, Elsie Manchester, and Gladys Latimer. Also seen here is the principal, James McGroty (at the rear right). Absent from the photograph was Alice Killeen. In 1904, many their age had already left school. (Montville Historical Society.)

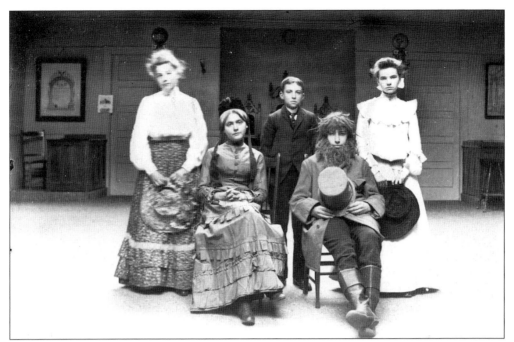

A THEATRICAL CAST. This unusual photograph is of particular interest in that it was apparently taken in the Masonic meeting room on the third floor of the 1897 Palmer Memorial School. Note the "G" above the ritual chairs. Standing in the rear are, from left to right, Mae Walsh, Milton Bogue, and Maud Wood. Seated are Edith Austin and a young man so thoroughly disguised that he is unfortunately not identified. (Montville Historical Society.)

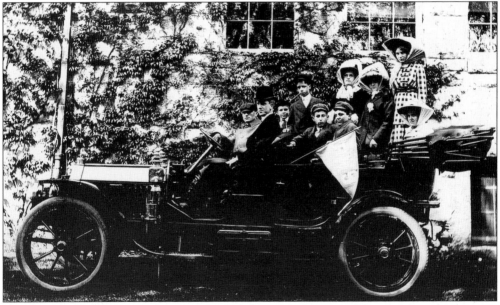

A SCHOOL OUTING. Complete with a very faint "P.M.S." on their pennant, these young people, probably a graduating class, prepare to depart on an automobile adventure. More than likely, the big chauffeured, right-hand drive touring car was provided for the occasion by one of the Palmers. (Montville Historical Society.)

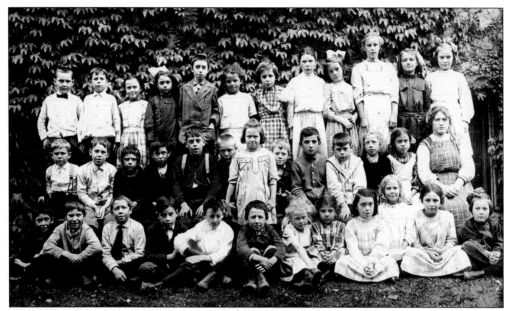

THE FIRST AND SECOND GRADES, 1912–1913. The full gamut of human character seems to be displayed in the individual faces of these Palmertown children. Their school's ivy-covered walls have the appearance of permanence, but that was soon to change. (Montville Historical Society.)

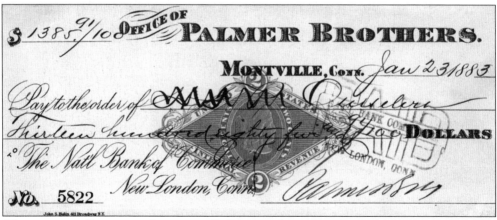

"PAY TO THE ORDER OF OURSELVES." One wonders what the endorsement looked like. (Montville Historical Society.)

THE RUINS OF PALMER
MEMORIAL SCHOOL.
On December 5, 1914, the
beautiful school was destroyed
by fire. (Charles Dennis.)

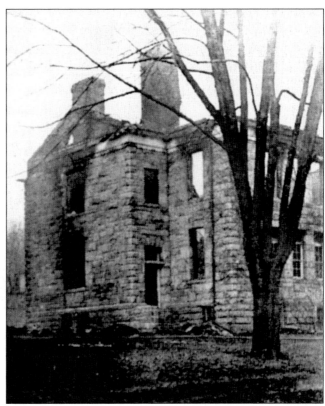

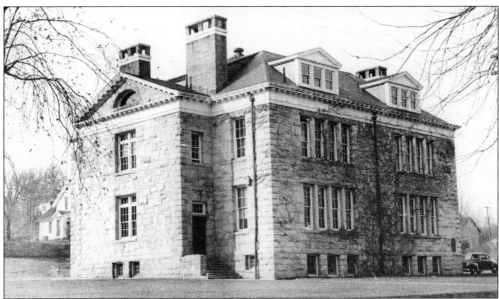

THE SECOND PALMER MEMORIAL SCHOOL. When the school burned, two of the four sons of
Elisha Palmer who had given the funds to build it were no longer living. But family pride and
public spirit resulted in a new school being completed in 1917. Although similar to the original,
it was of fireproof construction. The second Palmer Memorial School today houses the
Montville Alternative High School. (Montville Board of Education.)

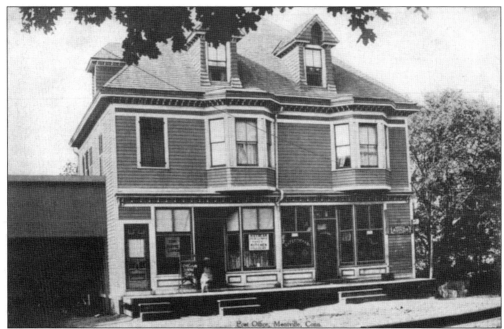

THE MONTVILLE POST OFFICES. The first so-called Montville post office (note the caption at the bottom of this postcard) was actually located in Chesterfield. At Palmertown, it has moved around quite a bit in 150 years, but never very far. It was sometimes located within grocery stores, as indicated by the caption of this postcard, which was cancelled in 1908. This Route 163 building still stands.

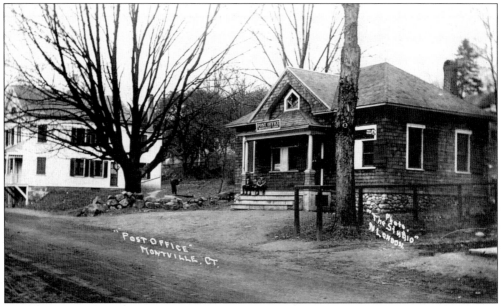

THE POST OFFICE, C. 1912. In the early 20th century, a well-designed Shingle-style building was erected especially for postal use. Later on it was extended forward and very heavily altered into a store, and eventually it became a home. The Greek Revival–style house at the left was torn down only recently and is now a parking lot. (Charles Dennis.)

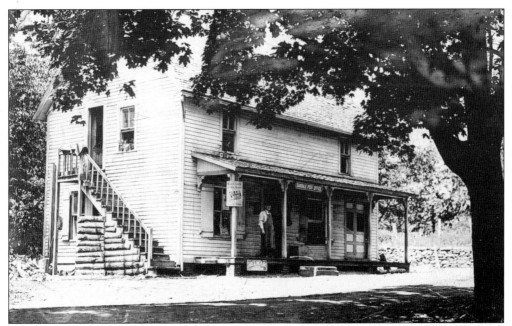

THE OAKDALE POST OFFICE. In 1881, the Oakdale post office was established. The premises were shared with a store; the building still stands. Today, Oakdale addresses designate an area far exceeding the little village that grew up around the Oakdale Mill. (Raymond Library.)

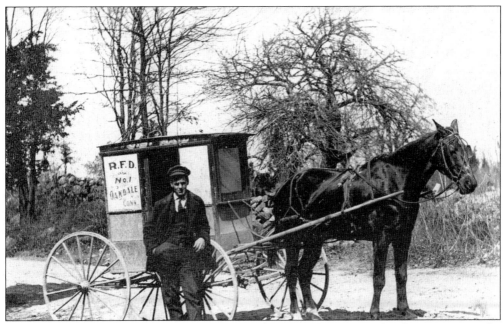

RURAL FREE DELIVERY, 1909. Harry Auwood and his horse pose for the camera on the Oakdale RFD route.

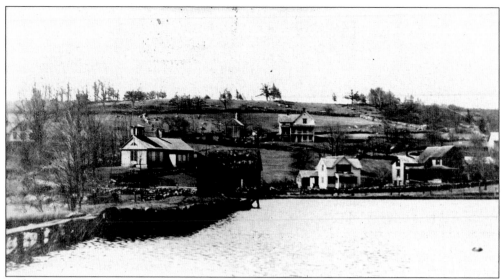

THE OLD TOWN HALL ACROSS RED MILL POND. Seen here from the present Route 163, a dam was built by Gideon Palmer *c.* 1852 and later served the Montville Paper Company. The name of the pond recalls the color of its long-gone wooden factory, just out of view to the left. An open, agricultural landscape was once as much a part of Palmertown as were its industries. (Montville Historical Society.)

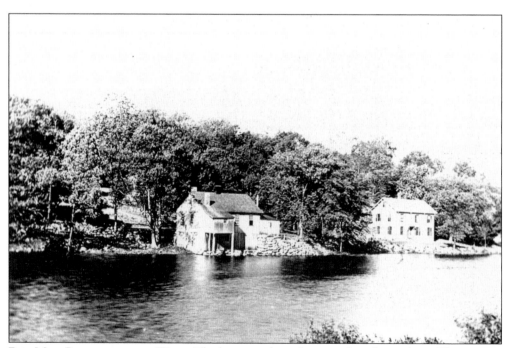

RED MILL POND FROM THE WEST. The house at the right was taken down about 25 years ago. The identity of the building at the center is unknown, but the purpose of the little lean-to jutting out over the pond may be guessed at. (Montville Historical Society.)

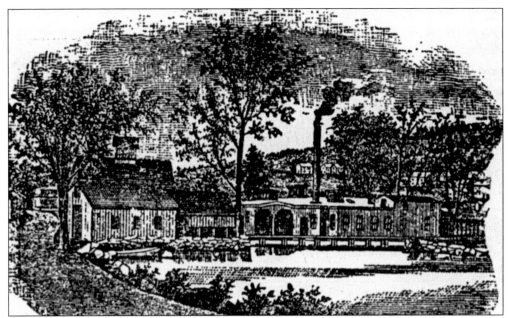

THE MONTVILLE PAPER MILL. Established in 1859 as the Montville Paper Company, and from 1866 the property of Carmichael Robertson, the Red Mill was still in use in 1940 when it was badly damaged by fire. In this engraving, looking south, Palmertown's front road (Route 163) is seen at the left, with the Palmer Brothers Company mill barely visible at the curve in the distance; the company's stockhouse with its large cupola is partly obscured by another structure. The wooden Red Mill, with its smokestack, stands just beyond the millpond dam. Today, Bragdon's Garage and B&S Cycle are located on this site.

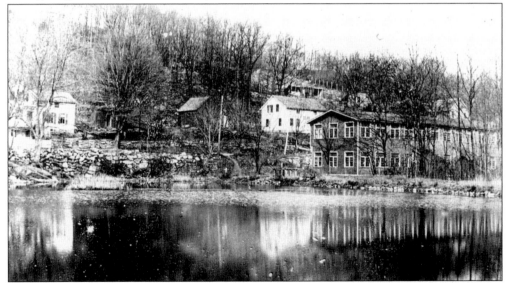

HURLBURT'S POND. Alfred Hurlburt built a twine and rope factory in 1866, but it burned a few years later. After a second disastrous fire, the site was sold to a bicycle manufacturer and this building was erected. Its Route 163 site is identifiable by the two-family house at the center. The dam was later breached and the pond filled in for expansion by the Robertson Paper Box Company. (Montville Historical Society.)

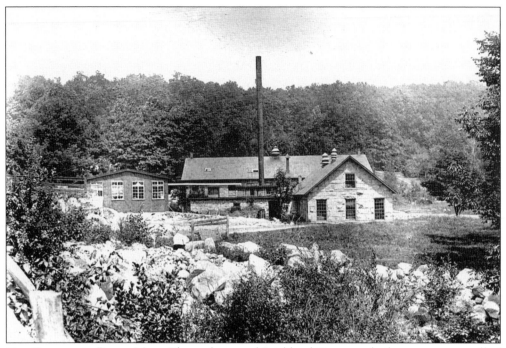

THE ROCKLAND PAPER MILL. The aptly named Rockland Company built a new paper mill of stone in 1868 and produced newspaper there. Carmichael Robertson acquired the company in 1875, installed a new paper machine, and made manila until his death in 1889, after which his sons Alex and Tryon carried on the business. In 1895, the Rex Box Company erected the building seen at the left in this view and began to make paper boxes with material produced next door. But "set-up" paper boxes were expensive. They took up valuable space during shipment to the customers that used them for packaging, so they were entirely impractical for basic commodities and other inexpensive consumer items. That was soon to change, after a method was accidentally discovered within the industry of using printing presses to cut and crease cardboard. Costly set-up boxes gave way to inexpensive folding ones, which could be shipped flat. Alex Robertson fully grasped the commercial significance of this development, and in 1897 the company purchased the Rex Box Company. By the turn of the century, folding boxes were being produced for a number of leading product manufacturers. (Copyright Mystic Seaport, Everett A. Scholfield Collection, Mystic, Connecticut.)

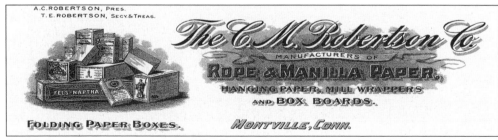

C. M. ROBERTSON LETTERHEAD. The business was incorporated as the C. M. Robertson Company in 1902. Its stationary proudly displayed images of the packaging the company produced for popular consumer brands. Fels Naptha Soap, James Pyle's Pearlene, Newport Pins, and Athenian Currents are all represented here.

CARMICHAEL ROBERTSON (1823–1889). Born at Pennicuck, Scotland, Robertson learned the papermaking trade. In 1865, he bought the Montville Paper Company (the so-called Red Mill) with two partners, then gained sole ownership. In 1875 he purchased the stone Rockland Mill, just upstream. By 1882, Robertson was producing two tons of paper a day. He built a third mill in 1886. Robertson was not the first to make paper in Montville, nor did he live to see his company become a leader in the packaging industry after its entry into the folding box business. But the credit belongs to him for establishing Montville as a center of paper manufacturing, which it has remained.

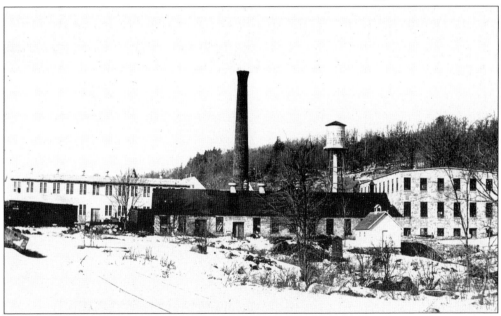

THE OLD STONE MILL ON THE OXOBOXO. With the addition of folding boxes, the company's business boomed. Another story was added to the old Rockland Mill (at the right), with an effort made to carry out the work in the same style. In 1921, Ralph A. Powers acquired a large interest in the company. Equipment was improved, new techniques were introduced, and, operating as the Robertson Paper Box Company, the mill became a leader in the packaging industry. The surviving 1868 mill always remained a link to the history of the site and the many who worked there. But in 2004, current owners Rand-Whitney reduced the Old Stone Mill to rubble. (Montville Historical Society.)

C. M. ROBERTSON COMPANY WORKERS' HOUSING. The company followed a policy of providing adequate and attractive housing as it expanded. This was one of several similar examples that stood in a neat row on upper Maple Avenue until Rand-Whitney tore most of them down a few years ago. (Montville Historical Society.)

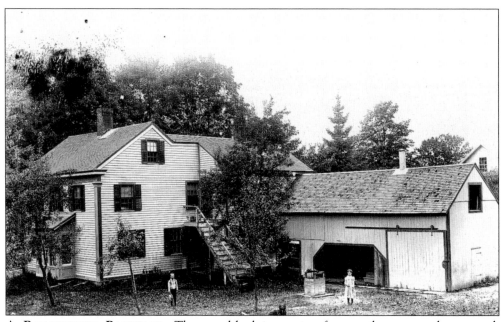

A PALMERTOWN BACKYARD. The woodshed is empty after another season has turned. (Montville Historical Society.)

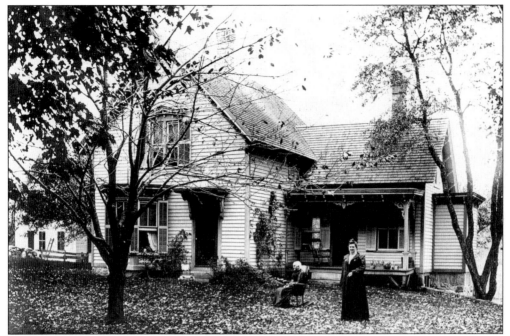

THE HOME OF WILLIAM L. WEBSTER. Webster, seen on page 52 in a portrait of Palmer Brothers foremen, lived in this fine house. It stood on Maple Avenue until recent times, when it too was bulldozed by Rand-Whitney and became a parking lot. (Connecticut Historical Society Museum, Hartford.)

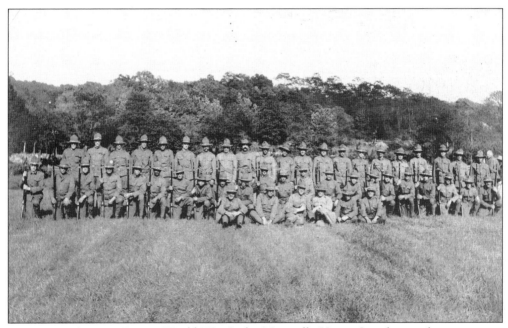

THE HOME GUARD. During World War I, the Montville Home Guard poses for its portrait. Charles E. Ramage was captain. (Montville Historical Society.)

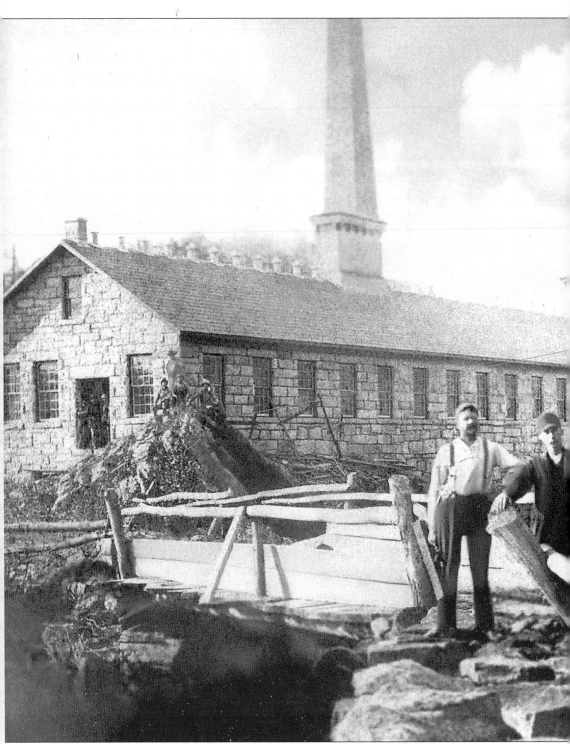

THE BANK PAPER MILL, 1886. Carmichael Robertson built his Bank Paper Mill in 1886 using stone quarried at the site. In this fascinating view, the builders pose with their tools. Several industries have existed here over the centuries. In 1837, Henry Wheeler built the

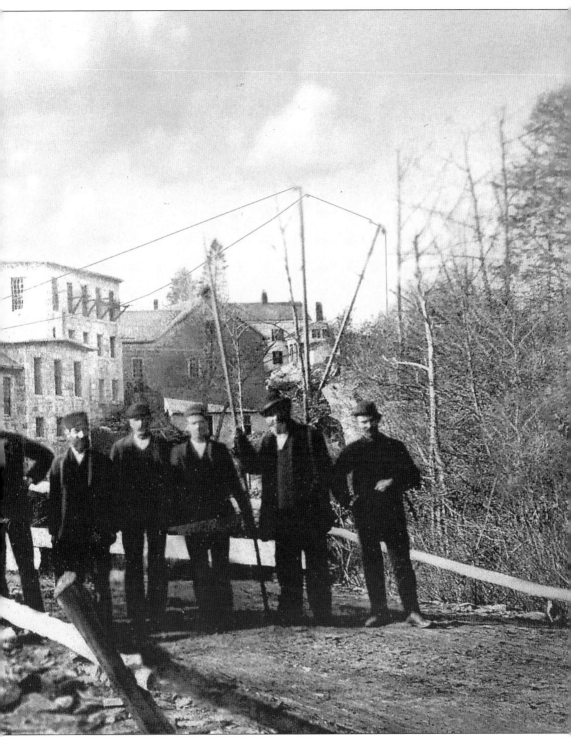

second of two cotton mills that have stood here; the large millpond to the north bears his
name. Wheeler's house is still standing and is just visible at the rear of the photograph.
Robertson's special product from this mill was used for currency, stock certificates, and the like.

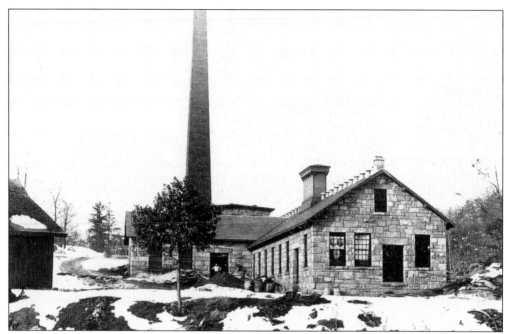

THE BANK MILL, EARLY 20TH CENTURY. As with other mills along the Oxoboxo, this 1886 stone building was beautifully constructed. But in later years it became obscured behind various hodgepodge additions, and today is mostly hidden from view, the pride taken by the builders long forgotten. Even today, the complex is still referred to as the Bank Mill. (Montville Historical Society.)

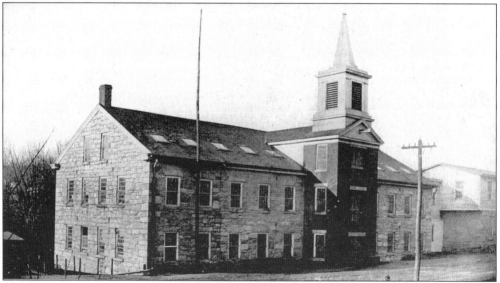

THE MONTVILLE WOOLEN COMPANY. This fine old stone mill with its church-like belfry was built by Col. Frank B. Loomis in 1846. It went through successive owners and finally became the Montville Woolen Company after 1888. The location of this mill, which has been gone for many years, has become confused. In fact, it stood just south of the stone house at 262 Route 163, which itself was rebuilt out of the first story of the annex at the right of this photograph. A blocked-up doorway that once led into the main mill building can still be seen.

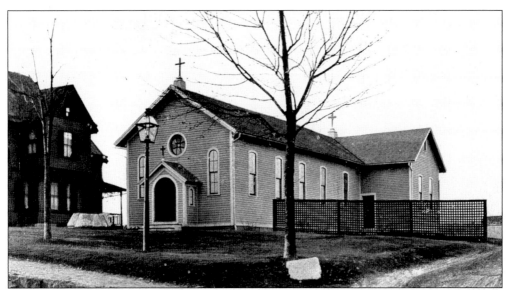

ST. JOHN'S ROMAN CATHOLIC CHURCH. A growing Irish immigrant population found employment in Montville's mills, and in 1866 the bishop of Providence purchased property on which stood a newly built stable; it became the Church of St. John the Evangelist. St. John's Parish was established in 1887, and the rectory, at the left, was built the following year. These buildings were replaced by the present church and parking lot in 1956–1957.

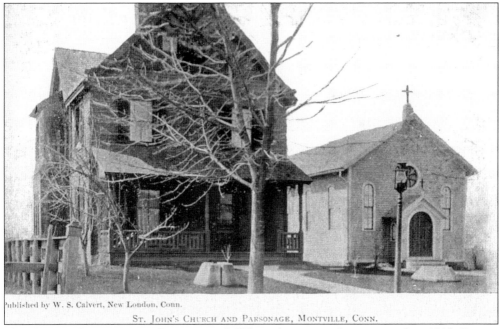

Published by W. S. Calvert, New London, Conn.
ST. JOHN'S CHURCH AND PARSONAGE, MONTVILLE, CONN.

"ST. JOHN'S CHURCH AND PARSONAGE." When this postcard was printed c. 1905, Roman Catholicism was still a relatively young presence in eastern Connecticut, where Congregationalism had been adhered to for over 250 years and dissenters such as Baptists had only become accepted over time. The caption writer's use of "parsonage" to describe a Catholic priest's residence is an interesting reminder of an era when non-Protestant (and even non-Christian) immigrants were challenging the Yankee-descended establishment.

71

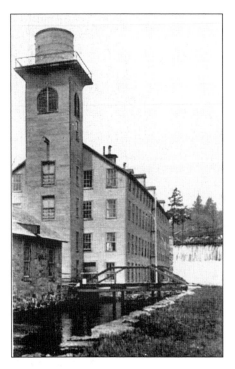

PEQUOT MILLS. In 1860, Norton Brothers and Hiram Crosby of Norwich purchased an oil mill first built *c.* 1803 on an early sawmill site. They greatly enlarged the old building. Extensive stone buildings were added, and woolen machinery was put in. In 1871, these mills came into the control of Henry B. Norton and Lorenzo Blackstone and were converted from woolen production to cotton. By the 1890s, the Pequot Mills contained 238 looms and 8,064 spindles and employed about 130 hands.

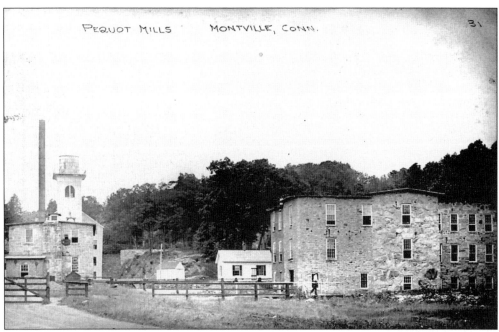

PEQUOT MILLS, SEEN FROM THE SOUTH. The stone buildings erected *c.* 1860 by Norton Brothers and Crosby are prominent in this view from the south. After lying derelict for many years, they are again in use today, although the characteristic flat roofs have been changed. A former mill tenement of matching low-pitched granite construction still stands nearby at the southbound I-395 ramps. (Charles Dennis.)

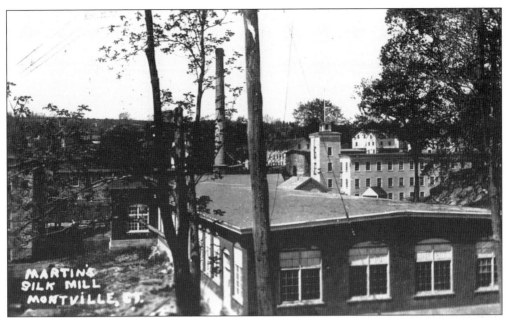

THE J. B. MARTIN COMPANY. J. B. Martin, silk manufacturers, owned the Pequot Mills from 1919, and through the early 1930s the company employed over 200 on three shifts. The mills finally closed in 1941. The old wooden mill seen at the right rear of this photograph appears to have lost its upper story at some point, along with much of its tower. (Compare this photograph with the one at the top of page 72.) What still remained was later used for the storage of plastics and foam rubber, and the building was destroyed by a spectacular fire in 1954. The low brick mill in the foreground is hardly changed today. (Charles Dennis.)

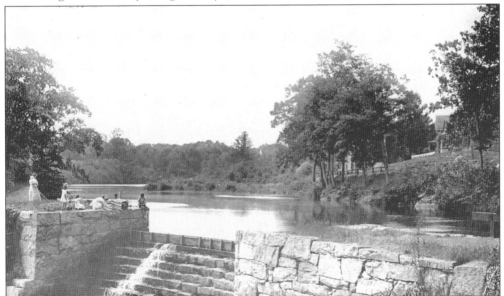

THE PEQUOT MILLS DAM. Norton Brothers and Crosby also built an impressive stone dam across the Oxoboxo. It was higher than the previous dam and had a 46-foot fall. The lower portions of the brook were called "Cochikuack" by the American Indians and "Saw Mill Brook" by the English. The road on the right bank of the pond is now Route 163. (Charles Dennis.)

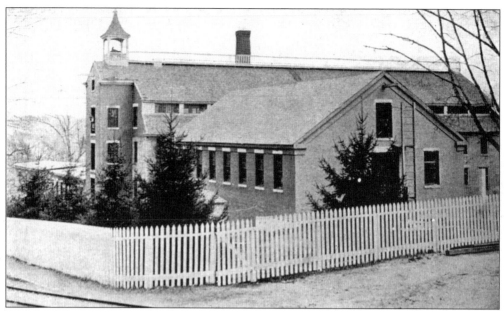

UNCASVILLE MILL. In 1823, Peter and Henry Richards erected a five-story, 120- by 40-foot stone cotton factory. Their business failed in 1830, perhaps to the satisfaction of Lorenzo Dow, the defendant in their great 1827 water-rights lawsuit discussed on page 30. The mill then came into the possession of Charles and George Lewis. They made extensive improvements, including the addition of the brick mill seen in the foreground of the photograph above. The Lewis operation was reorganized as the Uncasville Manufacturing Company in 1848, and further extensions to the plant were made over the years. Denim was the principal product. The steep grade of the Palmertown railroad branch is very apparent in the image below, as are the well-kept grounds. In 1923, the mills were taken over by the Sidney Blumenthal Company under the trade name Shelton Looms. Output changed to include velvet, mohair, and other upholstery material. Since 1964, the buildings have been home to the Faria Corporation. The 1823 mill still stands, although its neat little belfry is gone. The oldest remaining mill on the Oxoboxo, it is a significant historic building in its own right. Several very early mill houses still stand nearby on Blumenthal Drive, with later examples on Crescent Street.

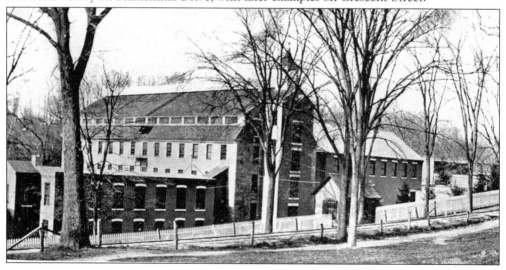

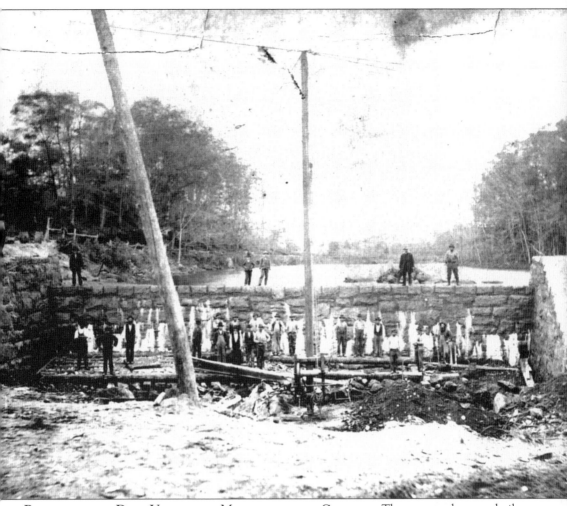

REPAIRS TO THE DAM, UNCASVILLE MANUFACTURING COMPANY. The present dam was built in the 1870s, flooding a much larger area than had been previously and creating a total fall of the Oxoboxo to the mill of about 40 feet. Repairs appear to be underway in this photograph: the water level is drawn down, a derrick is in place, and a large crew is engaged in work behind and below the south spillway. Note the mineral deposits that have resulted from leaks, a clue to the nature of these repairs. Similar work was necessary not many years ago. (Gary Wisniewski.)

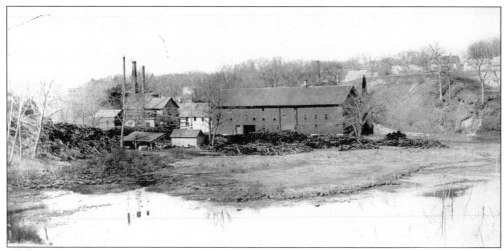

JOHNSON'S DYE WORKS. Serving the textile trade, William G. Johnson extracted vegetable dyes from exotic woods at the Dye Works he established at the mouth of the Oxoboxo in 1834. Business steadily increased for many years, and after Johnson's death in 1892, operations continued under the ownership a son, Henry C. Johnson. At the turn of the 20th century, consumption of dyewood was estimated in a publicity article to be 15,000 to 25,000 tons annually, "from Hayti, Port de Paix, St. Marc and Gonaives." In this photograph, taken at low tide, valuable stocks of dyewood await chipping and grinding, distillation, reduction, and refinement. The Dye Works produced black, brown, and blue dyes, but it specialized in black. (Montville Historical Society.)

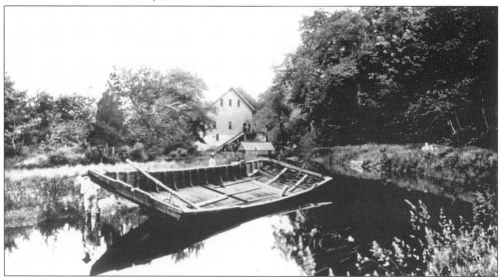

THE MOUTH OF THE OXOBOXO. The Dye Works were situated to take power from the Oxoboxo but were some distance away from the company's Thames River wharf. The imported dyewood was transferred to flat-bottomed scows and rowed around through Haughton's Cove. A canal allowed access to the works. The business prospered for years, but by 1902 Henry C. Johnson's accounts were in turmoil. He assigned his property to a trustee, and his wife attested that he was incapable of managing his own affairs. After the bank foreclosed and other interests bought the premises, it was not long before the site disappeared in 1910 under the waters now called Gair's Pond. (Montville Historical Society.)

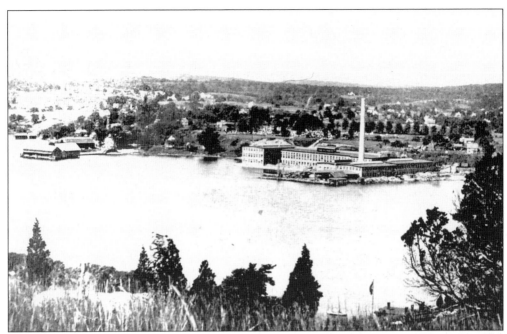

THE THAMES RIVER SPECIALTIES COMPANY. On November 23, 1909, the *New London Day* reported that between 150 and 200 men were employed daily in building the new paper mill at Uncasville. Others were building a dam for a new process water reservoir. After about a year of construction, the big Thames River Specialties Company mill opened in 1910. (Montville Historical Society.)

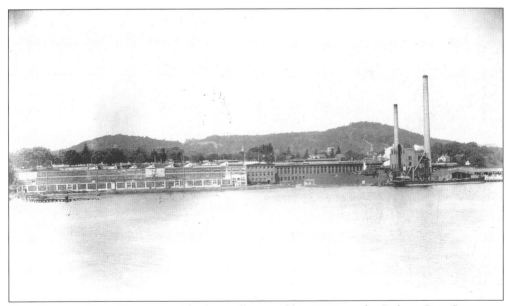

THE ROBERT GAIR COMPANY. The big mill was sold in 1921 to the Robert Gair Company, later part of Continental Can Company. In this photograph, probably taken in the 1940s, additions have filled in the riverfront all the way to Dock Road. Paper production continues today under owners Smurfit-Stone Container Corporation. (Raymond Library.)

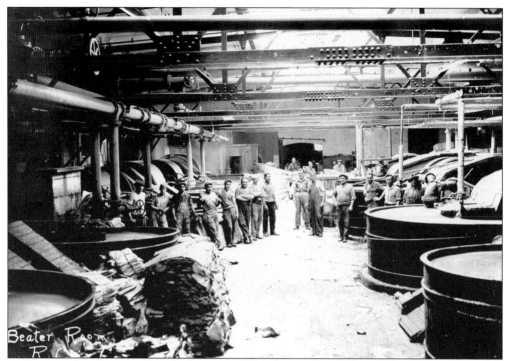

THE BEATER ROOM AT THE ROBERT GAIR COMPANY. The first stage of cardboard production is seen in this 1920s view. Waste paper is broken down with hot water in large mixing vats. The resulting pulp is then filtered to remove impurities before being pumped to the paper machines. (Raymond Library.)

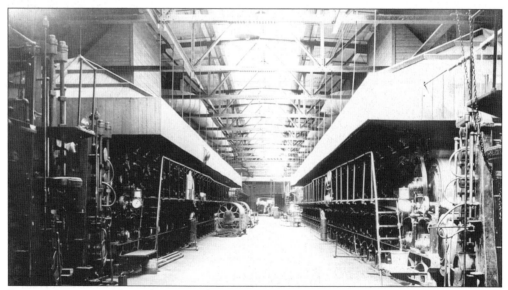

PAPER MACHINES. The pulp is spread on a moving screen as water drains off, and it is then squeezed between heavy cylinders. After running through a long series of rotating dryers, the resulting brown paper is wound into large rolls for further processing into cardboard. Nearly a century after it was first erected, one of these machines is still in use today. (Raymond Library.)

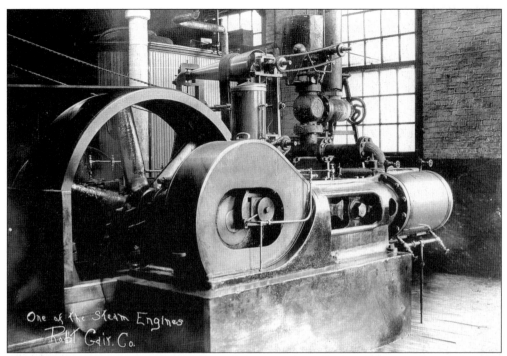

One of the Steam Engines
Robt Gair. Co.

A STEAM ENGINE AT THE ROBERT GAIR COMPANY. As mills grew larger, waterpower usually proved insufficient. At this paper mill, steam engines supplied motive power from the beginning. The standard of care and maintenance is obvious in this image, as are the hardwood floors and varnished woodwork in the engine room. (Raymond Library.)

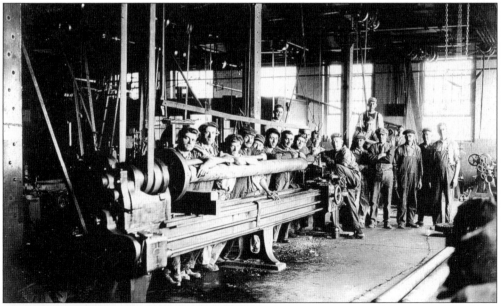

THE MACHINE SHOP. A less obvious part of any manufacturing process is the array of machines that make the machines or keep them in repair. Here, machinists and millwrights pose with a rather big lathe. Note the leather belts and overhead lineshafting, a typical installation before the use of individual electric motors became common. (Raymond Library.)

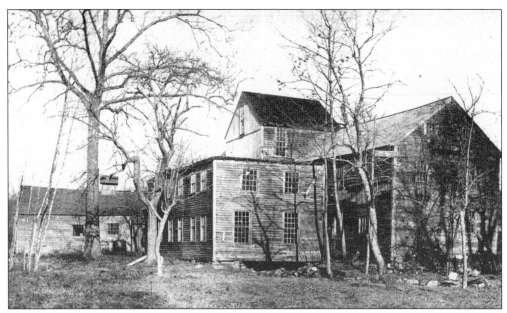

THE LEGACY OF INDUSTRY ON THE OXOBOXO, C. 1900. This is another view of the rambling old Scholfield Woolen Mill in its final days. After nearly 100 years, the Oxoboxo's waters have powered this mill's carding and spinning machinery and looms for the last time. Soon the mill will simply disappear. (Charles Dennis.)

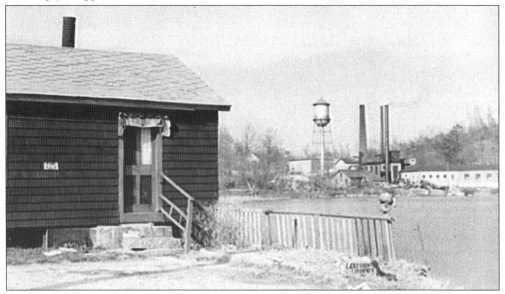

THE LEGACY OF INDUSTRY ON THE OXOBOXO, 1940. The Bank Mill was acquired in 1927 by the Inland Paper Board Company, which modernized the facility. A new boiler house and new smokestacks are apparent here, as is the familiar water tower, a rare survivor of its type at the time of this writing. Inland later merged into the Federal Paper Board Company. In this 1940 study in contrasts, the Bank Mill exudes American industrial power like a miniature of Ford's River Rouge plant. But it exuded other things, too, and it finally closed after anti-pollution legislation eliminated the distinctive colors and odor of the Oxoboxo of the era. (Photograph by Jack Delano, Work Projects Administration.)

Four

ALONG THE OLD MOHEGAN ROAD

In 1792, authority was granted to collect a toll on the old road laid out in the 17th century between Norwich and New London across the Mohegan reservation. This was the first turnpike in the state and the second in the nation. The monies thus collected were used to pay for the upkeep and improvement of the road. In the early 19th century, proceeds from a lottery financed extensive relocations and grade improvements, establishing more or less the course of the present Route 32. This chapter illustrates some once-familiar scenes and landmarks on and near the old turnpike, proceeding from south to north.

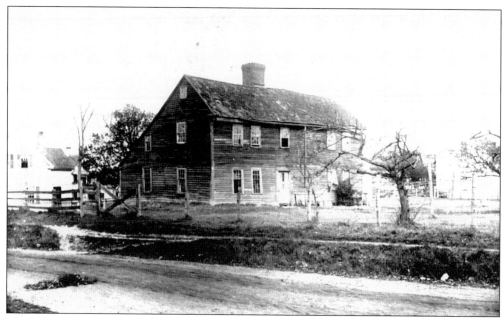

THE NATHAN COMSTOCK HOUSE ON LATHROP ROAD. This ancient dwelling, depicted not long before it was razed in 1917, was at one time owned by Nathan Comstock Jr., who was captured and held prisoner in England for seven years during the Revolution before escaping and returning home. The house had previously belonged to his grandfather Daniel, who settled in what is now Uncasville *c*. 1700. The Comstock farm stretched from the Thames River to the old course of the Norwich and New London Turnpike, now Lathrop Road. (Montville Historical Society.)

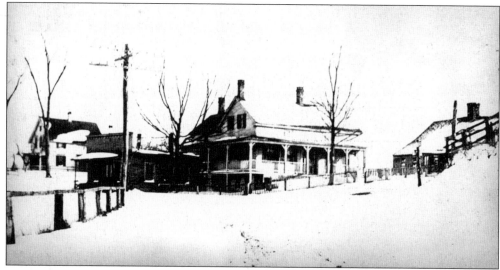

DEPOT ROAD AND LATHROP ROAD. The old turnpike course, which approximated the route laid out by Joshua Raymond and others across the Mohegan reservation to Norwich *c*. 1670, continued over what is now called Pink Row. About the time of World War I are seen L. G. Newton's house (at the center) and Newton's Store, later Florman's (at the left). At the far right, the ancient salt-box roof of the old Comstock house sees out its last days along the old Mohegan Road. (Montville Historical Society.)

UNCASVILLE METHODIST CHURCH.
Crescent Street was part of the
extensive relocation and
improvement of the turnpike
starting in 1806, although the street
has now been bypassed.
The Methodists built a
meetinghouse here in 1835, and in
1871 they built this church on the
same site. The impressive building
was destroyed by fire after being
struck by lightning in April 1927.
Its replacement was built on a
different site.

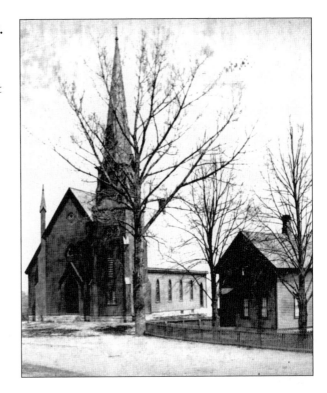

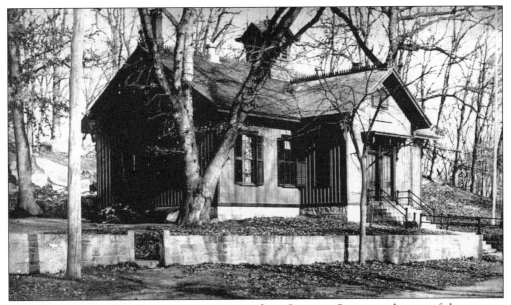

THE OLD UNCASVILLE SCHOOLHOUSE. Located on Crescent Street on the site of the present Teamsters' Hall, this was an attractive wooden building with several classrooms and was surmounted by an ornate cupola. The new Uncasville School (the present town hall) opened in 1918. (Charles Dennis.)

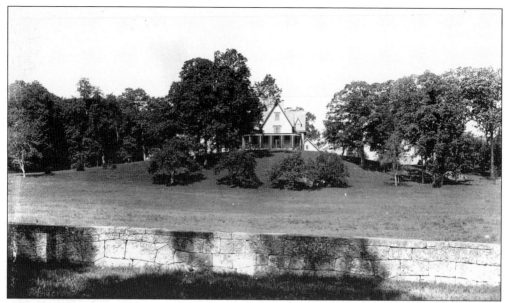

THE JOHNSON ESTATE. Dye Works owner William G. Johnson built an impressive Gothic Revival residence *c.* 1860; it still stands above the present Route 32. The beautifully built walls that surround it are attributed to Henry Matthews, a Mohegan stonemason. (Faith Jennings.)

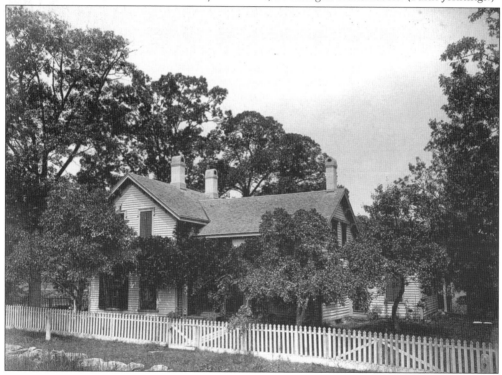

THE EDWIN C. JOHNSON RESIDENCE. Penciled on the reverse of this old photograph is a notation that this was the residence of Edwin C. Johnson from the 1860s. It seems very pleasant, although quite literally in the shadow of the home of his father, which was located on the hill across the road. This house still stands at 507 Route 32. (Montville Historical Society.)

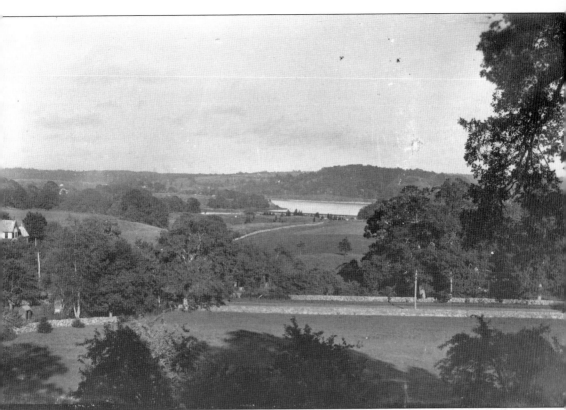

A View of the Thames from the Johnson Estate. This striking view from the William G. Johnson residence shows the beauty of the area before the meadows gave way to played-out gravel pits and the sewage treatment plant. At the left is the large house of Henry C. Johnson, which was on the site of the present Peoples Bank branch. (Faith Jennings.)

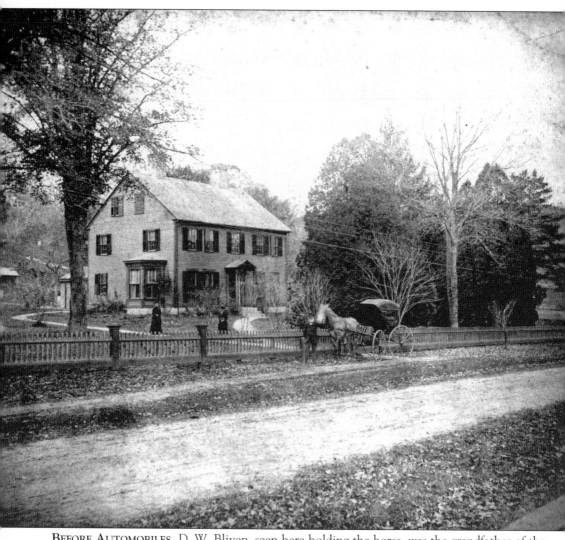

BEFORE AUTOMOBILES. D. W. Bliven, seen here holding the horse, was the grandfather of the well-known photograph collector who loaned this *c.* 1885 view. Mrs. Bliven and Nellie Bliven also appear here. This large early 19th-century residence was the home of several owners and superintendents of the Uncasville Mill over the years. Today it is the Backus Hospital walk-in clinic, and it has become rather architecturally confused compared to the original graceful lines seen here. (Faith Jennings.)

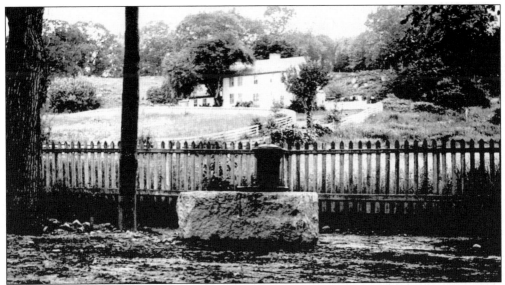

THE NATHANIEL BRADFORD FARM. A hillside landmark until not so many years ago, this old salt-box house was the home of Joseph Rogers c. 1750. When the turnpike opened in 1792, and for many years afterward, this home was the residence of Nathaniel Bradford, a farmer and "thorough Methodist." In the foreground is a public horse-watering trough, fed by Bradford's abundant spring. Today, these neatly fenced pastures have become Chucky's 24-hour gas station.

THE TOLLHOUSE. The tollgate authorized by the General Assembly in 1792 stood near the present Midway Shopping Center. This little house, built a few years afterward, was the tollhouse or keeper's residence. Early in the automobile era, when all things "Colonial" were in fashion, the Tollhouse was a tearoom, but as the years wore on it fell into decay, a victim of its location. When the little house was dismantled and rebuilt in another state c. 1980, Montville lost one more link with its history. Curtin Insurance Agency now occupies the site. (Montville Historical Society.)

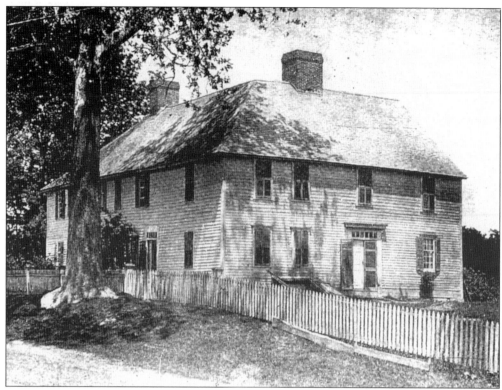

HAUGHTON'S TAVERN. In 1746, Sampson Haughton purchased a farm on what came to be known as Haughton's Cove. He owned this prominent house, which stood about opposite the present jail. In the turnpike era, it was operated as a tavern by his great-grandson William Whiting Haughton, who probably added the long section along the road at the left. The addition contained a ballroom for dancing and other social events. Haughton's tavern burned down early in the 20th century. (Montville Historical Society.)

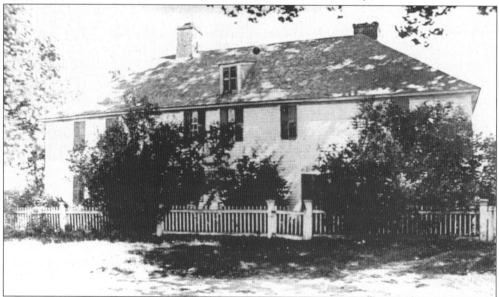

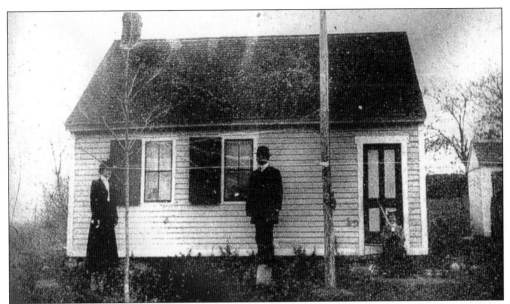

HAUGHTON SCHOOL. A number of the old district schools bore the names of nearby families. This one was in operation *c.* 1825. It closed with the opening of the new Uncasville School in 1918, but was occasionally reopened to cope with crowding. After its final closure, it was occupied as a house, then was razed to make way for Longo's Shopping Center. (Montville Historical Society.)

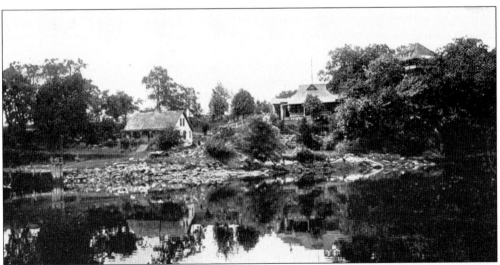

THE KITEMAUG ASSOCIATION. A private club established in 1879, the Kitemaug Association purchased Smith's Grove, a popular picnic spot just north of what was later named Point Breeze. Seen here, from left to right, are the association's wharf, caretaker's house, and dining hall. On the hill is the clubhouse, which boasted bowling alleys, billiard tables, and a large veranda. Kitemaug could be reached by railroad, private boat, or, on Wednesdays, the excursion steamer *Ella*. By the late 1890s, Kitemaug lost popularity, membership declined, and the property was sold. The clubhouse burned in 1915. During World War I, Camp Dewey of the U.S. Junior Naval Reserve occupied this area and the field nearby. High-tension-line towers were built here in 1919. (Charles Dennis.)

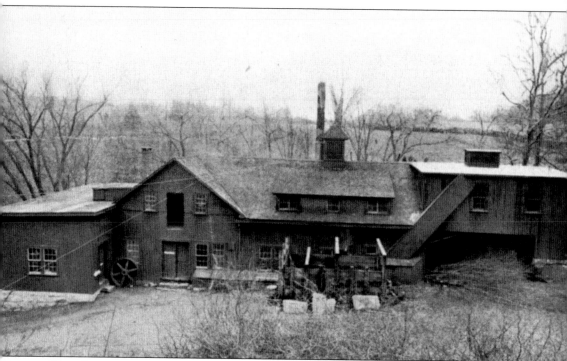

THE WITCH HAZEL MILL. At about the turn of the 20th century, Johnson & Company operated a witch hazel distillery at the outlet of Stony Brook, near the head of Haughton's Cove. The distillery extracted the once-popular astringent lotion from witch hazel brush (*Hamamelis virginiana*). In this panorama, the distillery stands on the unimproved Massapeag

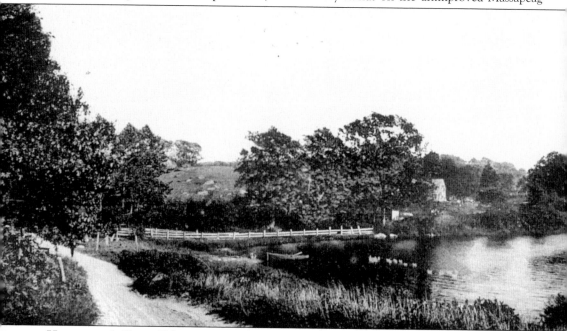

HAUGHTON'S COVE. "Massapeag," in the native language, properly describes both the cove and its banks. "Kitemaug" is actually out on the river, but is another place name that has now

Road, while in the background, open fields stretch to the Norwich–New London road below Haughton's Mountain. The buildings at the extreme right are approximately at the entrance to today's correctional facility. (Wayne Wisniewski.)

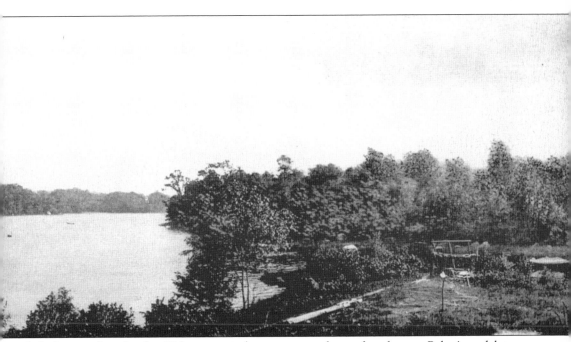

drifted somewhat. In the 18th century, the cove was often referred to as Baker's and later became Haughton's (or, corruptedly, Horton's), names reflecting early white landowners.

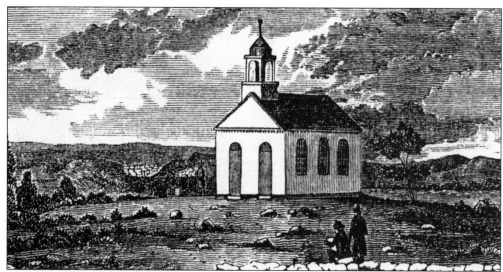

A SOUTHERN VIEW OF THE MOHEGAN CHAPEL. Norwich missionary Sarah Huntington and others raised funds to build a church at Mohegan. It was completed in 1831 on land given by three Mohegan women, Lucy Tantaquidgeon, Lucy Teecomwas, and Cynthia Hoscott. The Indian Congregational Church of Montville was organized in 1832, the congregation consisting of American Indians and whites. Mohegans had been members of the North Parish church since the 18th-century labors of Rev. David Jewett. The motivations for Christian ministry among the American Indians may depend on who is telling the story and when. This 1836 engraving, after a drawing by historian John Warner Barber, shows the original appearance of the building.

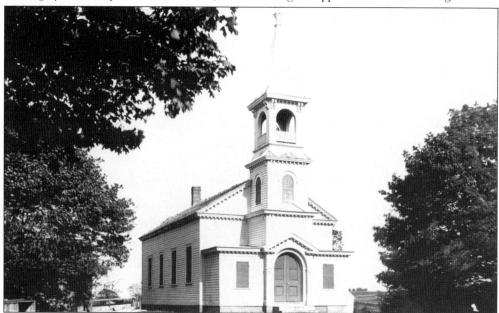

THE MOHEGAN CONGREGATIONAL CHURCH C. 1900. The simple little church was renovated c. 1875, and a tower and belfry were added in a more exuberant style typical of that era. By the late 20th century, the building was deteriorating, and within the past few years the Mohegan tribe has very thoroughly restored it. But with a large new addition and modern landscaping, the setting is rather changed from the bucolic image seen here. (Faith Jennings)

REV. SAMPSON OCCOM. A Mohegan, Occom was born in 1723, became a Christian, and was eventually ordained. He was a noted missionary among American Indians. In 1766, he went to England to raise money for Reverend Wheelock's Indian School at Lebanon, which he had attended. Occom's preaching attracted the attention of the Earl of Dartmouth, who helped secure substantial funds.

But Wheelock's dedication to American Indian education waned, and he relocated his school to New Hampshire, where it became Dartmouth College, chartered "for the education and instruction of Youth of the Indian Tribes in this Land . . . and also of English Youth and any others." Disillusioned, and as whites continued to take advantage of his people, Occom later led a group of Mohegans and others to resettle in upstate New York, where he died in 1792.

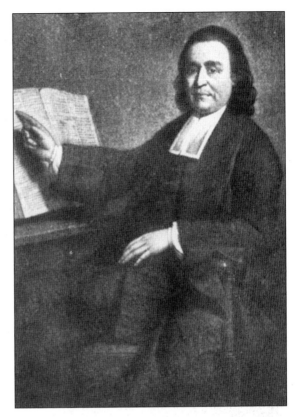

SAMPSON OCCOM'S HOUSE. This home was located approximately at the present corner of Route 32 and Occum Lane. (Montville Historical Society.)

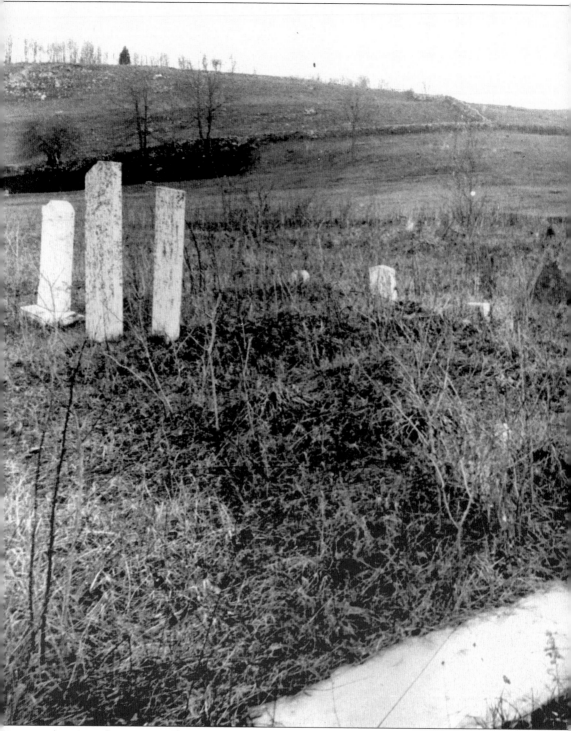

ASHBOW CEMETERY. This Mohegan burial ground still exists on Gallivan's Lane, but the panoramic Mohegan country seen in this view has been changed almost beyond recognition over the last century. Near the center is the headstone of Rev. Samuel Ashbow, another

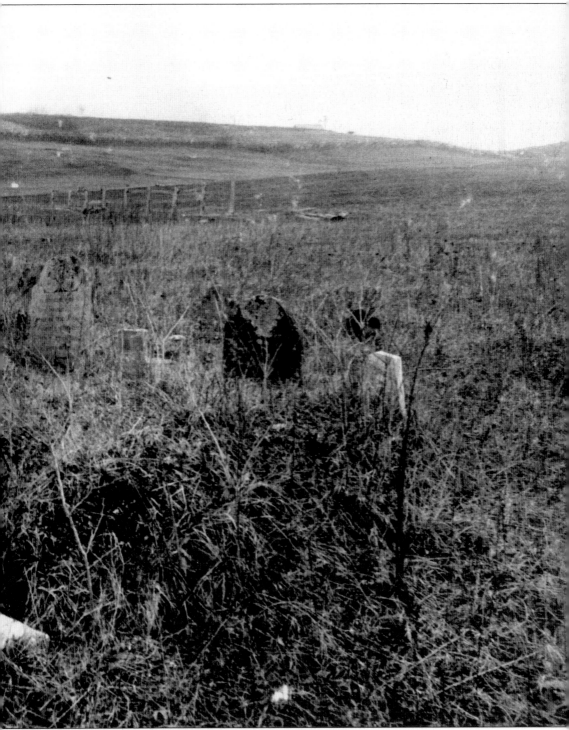

18th-century Christian Mohegan minister. The old turnpike ran in a slight cut near the fence posts in the middle distance. Route 32 follows the same course today. (Connecticut Historical Society Museum, Hartford.)

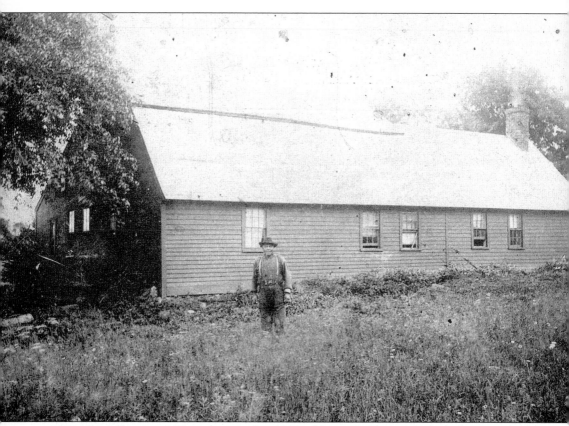

THE OLD FIELDING HOMESTEAD. In 1889, Moses Fielding stands before a rambling 18th-century house at Mohegan that appears indistinguishable from houses the English colonists built. According to Henry Baker's *History of Montville*, Henry Quaquaquid and Robert Ashpo had pleaded in a 1789 document presented to the Connecticut legislature that ". . . [T]he times are exceedingly altered, yea, the times are upside down, or rather we have changed the good times chiefly by the help of the white people. For in times past our forefathers lived in peace, love and great plenty. . . . They had no contention about their lands for they lay in common, and they had but one large dish, and all could eat together in peace and love. But alas! It is not so now; all our hunting and fowling and fishing is entirely gone, and we have begun to work our lands, keep horses and cattle and hogs, and we build houses and fence in lots. And now we plainly see that one dish and one fire will not do any longer for us. Some few there are that are stronger than others, and they will keep off the poor, weak, the halt and blind, and will take the dish to themselves. Yea, they will rather call the white people and the mulattoes to eat out of our dish, and poor widows and orphans must be pushed aside, and there we must sit, crying and starving, and die. And so we are now come to our good brethren of the Assembly, with hearts full of sorrow and grief, for immediate help. And therefore our most humble and earnest request is that our dish of succotash may be evenly divided amongst us, that everyone may have his own little dish to himself, that he may eat quietly, and do with his dish as he pleases, and that everyone may have his own fire." By 1860, what remained of the Mohegan reservation was indeed divided by the state into individual lots held in fee simple by tribal members. Most subsequently sold their land. (Montville Historical Society.)

COCHEGAN ROCK. There are perhaps more people familiar with Cochegan Rock than have actually seen it. Generally accepted to be the largest freestanding boulder in New England, this glacial monolith was the meeting place of Uncas and his council in the 17th century. The cave beneath was, according to tradition, the dwelling place of an 18th-century Mohegan named Caleb Cauchegan, although down into the 20th century its inhabitants were principally sheep. Cochegan Rock was given to the Boy Scouts of America by members of the Becker family, who once farmed here. (Montville Historical Society.)

"CACHEECAN BOULDER, THE LARGEST KNOWN IN THE WORLD." This tobacco advertising card of the 1920s includes actual dimensions, so its stupendous claim seems rather hyperbolic. It is a good example of the long use of American Indian imagery by the tobacco trade, which blurred stereotype with proper historical credit for the cultivation of the native plant.

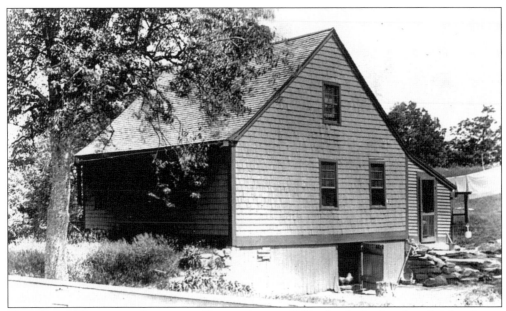

THE BAKER HOUSE AT COCHEGAN ROCK. From *c.* 1800, this little shingle-sided farmhouse near Cochegan Rock was the rather isolated home of Bliss Baker, his wife, Abigail, and their five children. The old cellar remains. Baker's farm was part of a very large tract that was obtained by his grandfather from Oweneco a century earlier. Even Henry Baker, Montville's late Victorian-era historian, conceded that "it is very probable" that many land grants were obtained from Oweneco "either while intoxicated, or by teasing him when sober." (Connecticut Historical Society Museum, Hartford.)

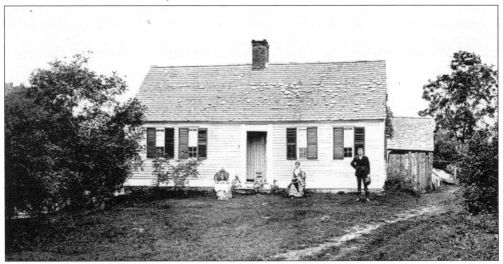

FITCH HILL FARM. Daniel Fitch (1665–1711) was a son of Rev. James Fitch, who was among the founders of Norwich. His family was influential with the Mohegan leaders, amassing large land grants. Daniel Fitch settled at Trading Cove, his lands running up what became known as Fitch Hill. At some later date, a descendant built the little house seen here on the homestead. It stood on the byway now called Old Fitch Hill Road and overlooked fields stretching down to the Norwich and New London Turnpike. When the house was taken down in the 1960s, it was still owned by descendants of Daniel Fitch. (Helen Coggeshall.)

Five
CHESTERFIELD

Chesterfield was established as a separate parish in 1769 within the old bounds of New London (now Montville) and Lyme (now East Lyme). Once again, political rather than religious autonomy was the primary motivation for the parish's separation. Within a few years it organized its own Congregational church, but it never really flourished. The old hillside graveyard south of the village marks its earliest site.

Connecticut's new Constitution of 1818 marked the end of Congregationalism as the established state religion, and the political functions of the parish had been largely superceded when Montville and East Lyme each incorporated in 1786. But religion was to emerge as a more defining characteristic of this once-isolated agricultural region in the 19th century. Baptist and Methodist churches competed side by side, then withered. By the late 19th century, Chesterfield was home to a sizable community of Jewish immigrants. But time has moved on, and little is left of the Chesterfield seen in these images.

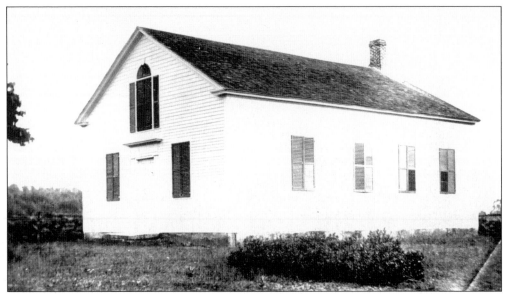

CHESTERFIELD BAPTIST CHURCH. A Baptist congregation was organized in 1824 and soon built this straightforward but pleasing building. Early on, the church grew rapidly, but its subsequent decline was dramatically underscored in 1875, when a number of its members left to become Methodists and built their own church just across Grassy Hill Road. In the end, neither congregation survived. In its 20th-century guise as St. John's Ukrainian Orthodox Church, the historic former Baptist church was destroyed by arson in 1981. (Montville Historical Society.)

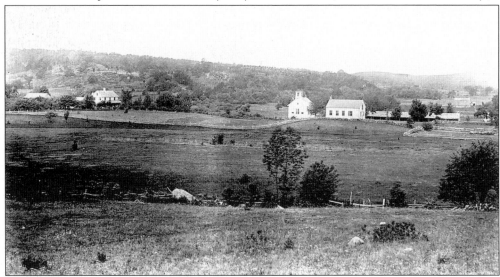

A PASTORAL VALLEY. From the south are seen the Methodist Church, with its belfry, and the more austere Baptist edifice. Chesterfield has seen the rise and demise of a surprising number of religious communities as dissenting Yankees gave way to newcomers with quite different traditions. At the time this photograph was taken in the mid 1890s, Chesterfield was already home to many recently arrived Russian Jews, who settled here with the assistance of the Baron de Hirsch Fund, a philanthropic enterprise with the goal of resettling them onto their own farms. Later arrivals here and elsewhere in Montville included Ukrainians and Poles. (Connecticut Historical Society Museum, Hartford.)

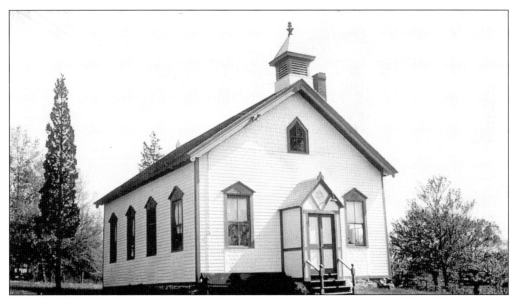

CHESTERFIELD SYNAGOGUE. In 1890, Hayyim Pankein was the first Jewish immigrant to buy a farm in Chesterfield. Others soon followed, eager to escape the tenements of New York. In 1892, the New England Hebrew Farmers of the Emanuel Society dedicated its new synagogue near the present intersection of Routes 85 and 161. In 1975, long after the Jewish community that once numbered as many as 500 people had dwindled away, the synagogue was destroyed by arson. (Nancy R. Savin.)

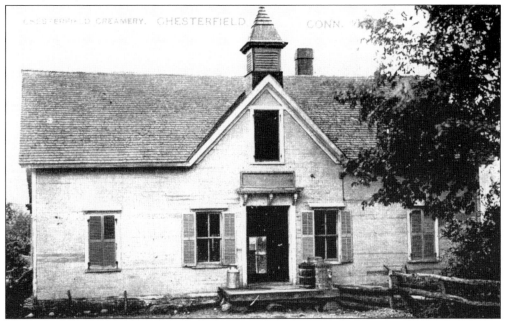

CHESTERFIELD CREAMERY. Also by 1892, Chesterfield's Jewish farmers opened a cooperative creamery, providing cream to New London hotels and restaurants and producing butter and cheese for the New York market. But over time it proved difficult to maintain a consistent supply of milk, particularly during the summer, when farmers took in many boarders. By 1915, operations had ceased, and the building was sold and converted to a house.

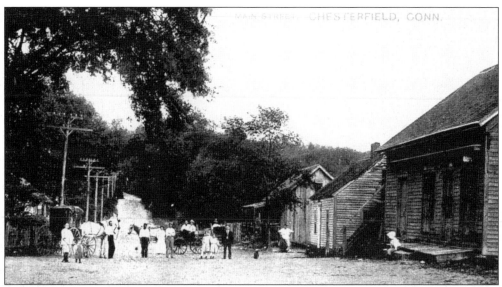

CHESTERFIELD FOUR CORNERS. The Hartford and New London Turnpike Company was incorporated in 1800 and opened an almost entirely new route, although it followed an existing course through the village. The middle building at the right was the tollhouse, although by the time this photograph was taken c. 1905, the tolls were long abolished. Railroads doomed the turnpike companies. The tollhouse still stands, as does Paty Schwartz's store at the far right, although the building is now drastically altered; it is one of several stores once owned by Jewish settlers. In days past, this location was known as Bishop's Corners, named after the late-18th-century inhabitants whose historic house still overlooks the spot.

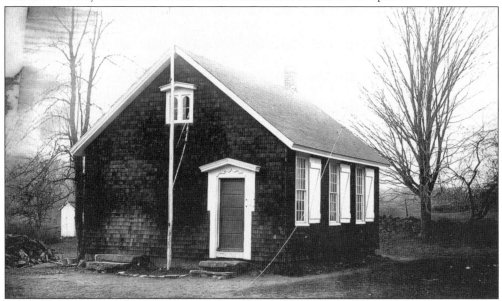

CHESTERFIELD DISTRICT SCHOOL. This building, which was located at the site now occupied by the Chesterfield Fire Department, displayed 20th-century modernizations that were applied to several of Montville's rural schools. The walls were shingled at some point, presumably to eliminate the expense of painting. Later on, the separate boys' and girls' entrances were eliminated, suggesting that this feature was long obsolete. (Nancy R. Savin.)

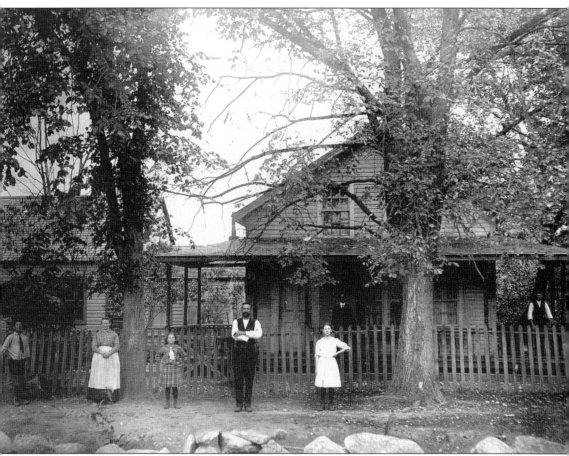

THE WOLF RITCH FARM ON FIRE STREET. Wolf Ritch (Reitche) is seen here at the center in front of his modest farmhouse on Fire Street *c.* 1900. In early 1892, there were 52 Jewish farmers within a five-mile radius. But of the original families that followed Hayyim Panken in 1890, half were already gone by 1894, although many others would come. Chesterfield's rocky, worn-out farms proved discouraging to these immigrants, who had little or no farming experience, and most soon pursued other endeavors. (Nancy R. Savin.)

LATIMER'S MILLS. These mills had been in the Latimer family for more than a 160 years when this photograph was taken in the 1890s, although the structures must have been rebuilt from time to time. In this very sharp photograph, one can see that the gristmill at the center has only just been re-shingled; the scaffold supports are still in place. At the left, the crude appearance

of the sawmill contrasts with its apparent capacity for the very large logs lying in the field. These mills stood near the town line on Silver Falls Road, an early highway now bypassed by Route 161. (Copyright Mystic Seaport, Everett A. Scholfield Collection, Mystic, Connecticut.)

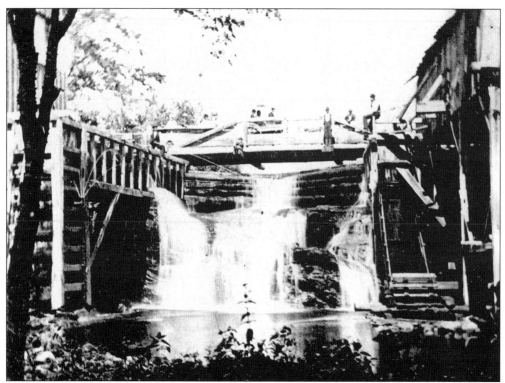

THE WATERFALL AT LATIMER'S MILLS. A natural cataract on Latimer's Brook was built up with a dam of logs to create a higher head of water. At the left in this early view, a wooden penstock channeled water into an unseen turbine, a 19th-century improvement at the gristmill. The sawmill retains an earlier, less efficient arrangement. A wooden truss bridge carries what was then the main road. (Faith Jennings.)

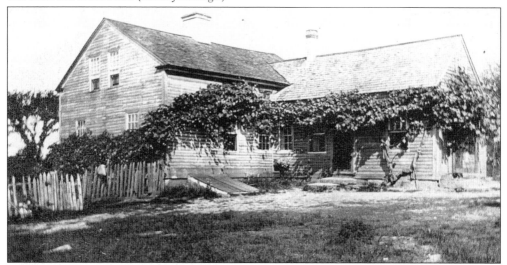

THE HARRIS E. DANIELS HOUSE ON EAST LAKE ROAD, C. 1910. Harris Daniels lived near the Waterford line in this rather idyllic, vine-covered, early 19th-century farmhouse, which is sadly no longer extant. Tastes have changed, and vinyl, not vines, would now be the aesthetic ideal. (Montville Historical Society.)

106

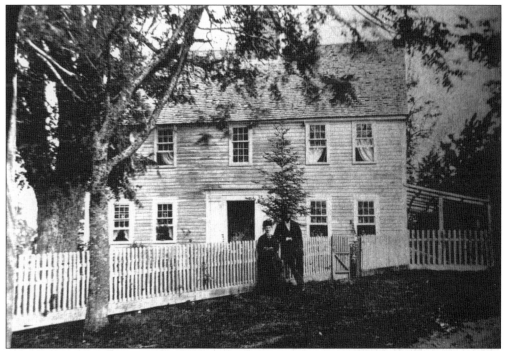

THE COL. JONATHAN LATIMER HOUSE. The Latimers were the leading family in early Chesterfield. Jonathan Latimer built this long-gone house c. 1745 on land that descended from his grandfather. As colonel of the Third Regiment of the Connecticut Militia in 1781 during Benedict Arnold's raid, he was censured for failing to take a more active role in bringing his forces into engagement with the enemy. In 1790, Colonel Latimer and seven of his sons left to resettle in Tennessee, but he never made it, dying en route. The dirt path seen here is now Route 161. (Faith Jennings.)

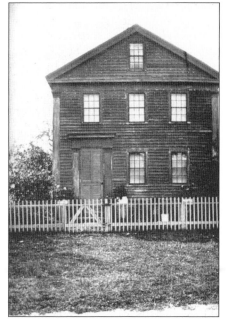

THE COURTLAND C. DANIELS FARM ON EAST LAKE ROAD. A 1905 biographer wrote, "In 1862 Courtland C. Daniels purchased the Anson Ames farm near the Waterford town line, over 200 acres in all, a great portion of which is in a good state of cultivation. He is one of the well-to-do agriculturalists of the town of Montville." Weather-beaten when it was photographed not many years later, the old place later burned down, and the farm has reverted to woods. (Montville Historical Society.)

Dan D. Home. In 1905, a biographer described Dan Home as "the efficient first selectman of Montville, and one of the enterprising and progressive farmers of that town. . . . In political faith he is a strong Republican. . . . Fraternally he is well known, being a member of Uncas Lodge, No. 17, A.O.U.W., of Montville; of Thames Lodge, No. 22, I.O.O.F., of Montville, of which he has held all the offices; and of America Council, No. 84, O.U.A.M., of Montville, in which he has held all the offices and is past councilor." In 1902, Dan Dunglass Home (1861–1940) was elected first selectman. He was re-elected a number of times, and he later served for many years as town clerk. He is seen here out for a drive with his wife, Ada Idelia (Woodmansee) Home. (Montville Historical Society.)

Six

TRANSPORTATION AND MODERNIZATION

Montville's location between Norwich and New London, along with its own industrialization, insured it a seat at the steady parade of improvements in transportation. Today, one of the automobile's legacies is suburban sprawl, and in Montville the future seems to promise more of the same. These images help put the road to the present into perspective.

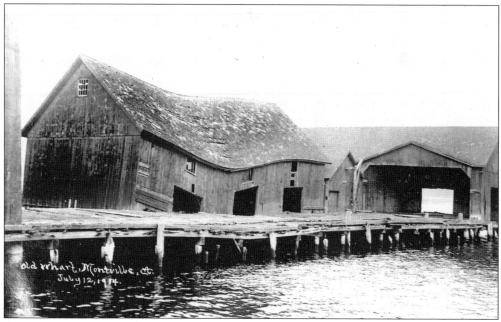

COMSTOCK'S WHARF, JULY 12, 1914. Seen not long before their destruction by fire on August 5, 1917, these warehouses would have been filled with market-bound manufactured goods before the completion of contiguous railroad links to New York and Boston late in the 19th century. Comstock's Wharf stood a bit south of the present town dock. Dock Road itself was once known as "the road to Gales Ferry," which says it all. (Montville Historical Society.)

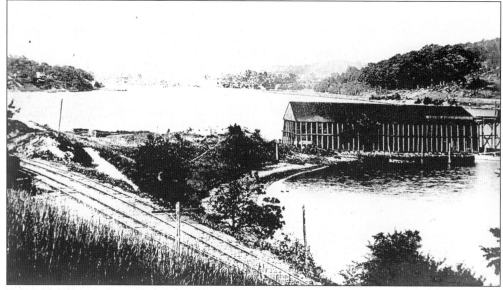

PALMER'S WHARF. In 1840, Gideon Palmer, who was, according to Henry A. Baker, "a great promoter of public improvements," bought a piece of land extending into the Thames River and built what became known as Palmer's Wharf. The wharf saw extensive steamboat traffic. Later, Lathrop's coal pocket was built, and it lasted until the Thames River Specialties Company mill was erected here, mainly on fill, in 1909–1910. The A.E.S. Thames power plant now dominates the site. (Montville Historical Society.)

JOHNSON'S WHARF, OCTOBER 21, 1899. Schooners landed cargoes of dyewood at Johnson & Company's wharf. The wood was then transferred into scows to be rowed around under the railroad trestle, through the cove, and up into the Dye Works. In earlier days, this was Palmer's Wharf; Lathrop's coal pocket is visible to the left of the schooner. The railroad station can just be made out between the schooner's masts. (Montville Historical Society.)

HAUGHTON'S COVE SEEN FROM MOUNT DECATUR. Facing upriver, a four-masted coastal schooner awaits a breeze while offering a last glimpse of commercial sailing in the Thames. (Montville Historical Society.)

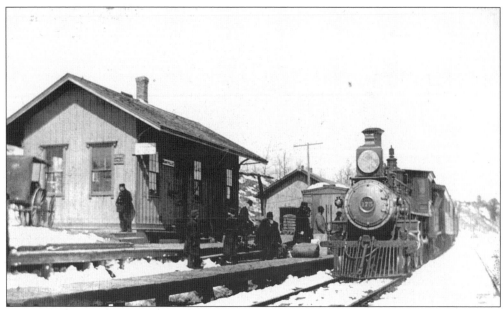

MONTVILLE STATION, 1900 OR EARLIER. The New London, Willimantic and Palmer Railroad opened in 1849. It was subsequently reorganized as the New London Northern Railroad and was later leased by the Central Vermont. This 1874-built locomotive was bought used by the New London Northern in 1890, and for the next 10 years it bore the number 175, as seen here. (Charles Dennis.)

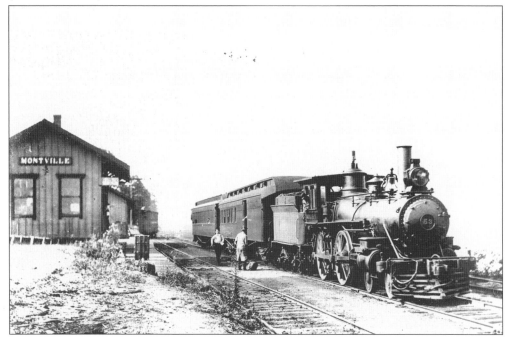

MONTVILLE STATION, 1900 OR LATER. This fine old Central Vermont locomotive was built in 1883 as the *Governor Smith* and was given the number 53 in January 1900. Changes are evident in this scene, including the removal of the raised platform. The old station and freight house lasted until the 1970s. (Jerry Bouchard.)

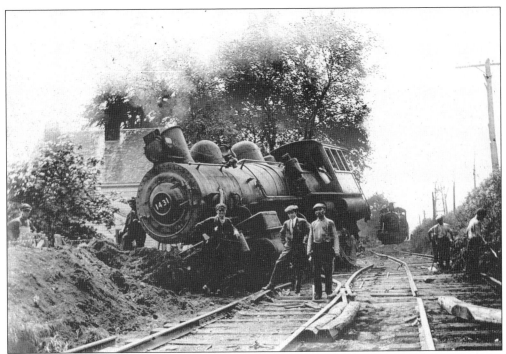

A DERAILMENT SOUTH OF DOCK ROAD, 1914. The damage appears slight after this northbound locomotive went its own way at a switch just south of the crossing. But it will still take some effort to clear up this mishap, and so the track gang is making temporary alterations to allow traffic to pass by. (Montville Historical Society.)

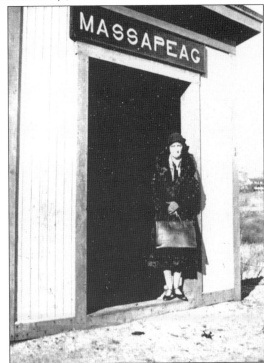

MASSAPEAG STATION. Massapeag (actually located at Massapeag Point) was a basic flag-stop railroad station. Unseen here, a small flag was the signal for the train to stop. Kitemaug was another flag-stop station. (Montville Historical Society.)

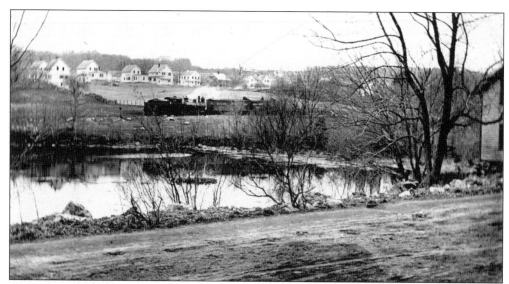

THE PALMERTOWN BRANCH. The manufacturers along the Oxoboxo were without direct railroad service until a branch line was built in 1899. It extended as far as Robertson Road and had sidings accessing several mills. There were no locomotive-turning facilities, and boxcars were pushed up or backed down as seen here. Hurlburt's millpond was later filled in to become Robertson Paper Box Company's front parking lot. Today, the field in the distance below Maple Avenue is the Rand-Whitney containerboard mill. (Montville Historical Society.)

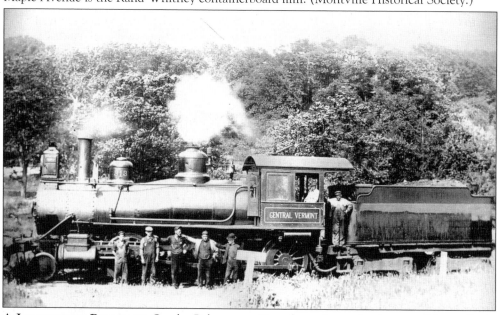

A LOCOMOTIVE PORTRAIT. On the Palmertown Branch not long after it opened for traffic in 1899, the engineer and fireman pose in their cab while the conductor and brakemen line up in front of Central Vermont's No. 313, an 1887 product of the Baldwin Locomotive Works. It went for scrap in March of 1924; the branch itself was abandoned following 1982 flood damage. Large train crews, including a fireman, were still mandated by union agreements well after the days of steam locomotives. These large crews were a significant labor cost when railroad revenues were declining. (Montville Historical Society.)

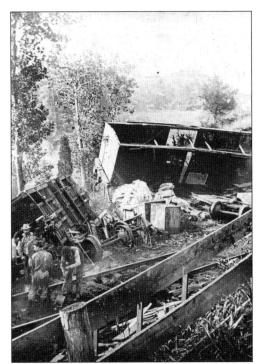
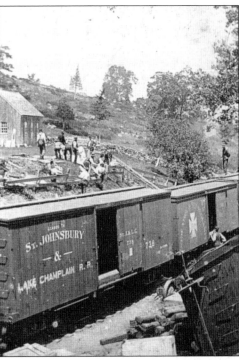

A WRECK AT KITEMAUG, BEFORE 1900. Following an impressive wreck at the Marvin A. Smith farm, the track is being made serviceable. Below, a train has been pushed south adjacent to the fields at Point Breeze, and a crew is salvaging the contents of another overturned boxcar. Marvin E. Smith was the photographer. (Charles Dennis.)

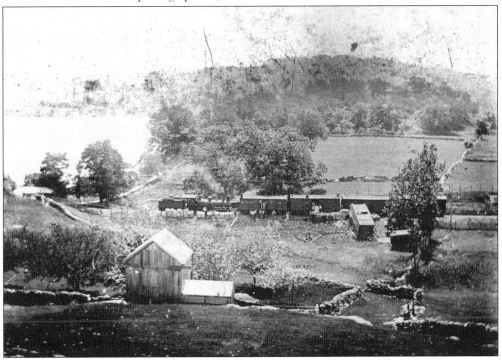

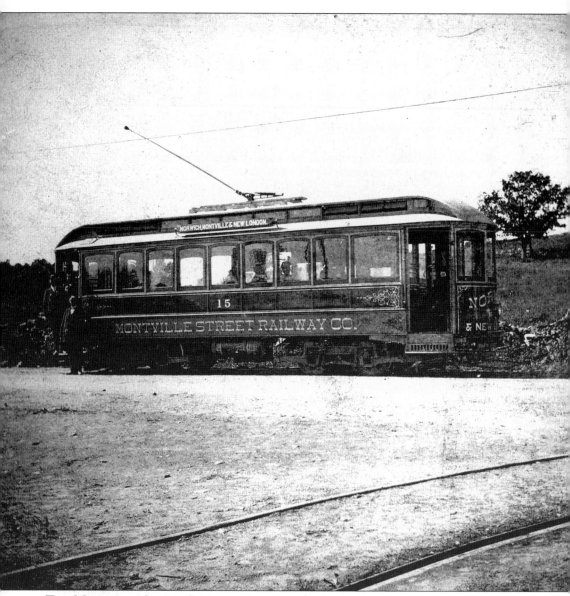

THE MONTVILLE STREET RAILWAY. In 1889, the Montville Horse Railway Company was incorporated. Technology was rapidly developing, and the company changed its name to the Montville Street Railway in 1893, projecting a link between New London and Norwich by electric trolley. But other than an abortive start, construction did not begin until 1899. On April 6, 1900, the *New London Day* reported that "An official of the Montville Street Railway line announced that cars would be running over the road May 15," and that "the big double truck cars stored in the car barn at Thamesville were being run over the Thamesville line to limber up the bearings." (Raymond Library.)

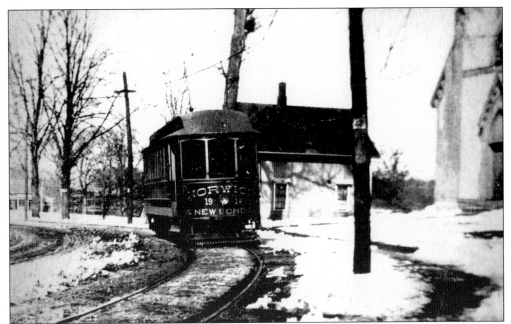

CRESCENT STREET, C. 1900. Car 19 of the Montville Street Railway rounds the bend past the old Uncasville Methodist Church on a snowy day. (Carol Kimball.)

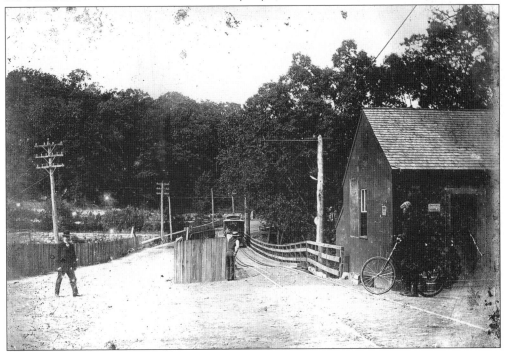

THE TROLLEY TRESTLE IN UNCASVILLE. The Montville Street Railway crossed the Oxoboxo on its own wooden trestle parallel to the old turnpike. In this view, looking north *c.* 1900, one of the cars is about to negotiate the trestle's awkward dip, over which slow speeds must have been in order. At the right is the company's rather unprepossessing waiting room. (Montville Historical Society.)

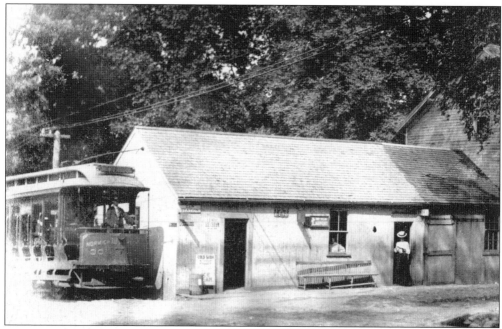

A SUMMER CAR AT UNCASVILLE. When trolleys were new, open-bench "breezers" were used during warm weather, but they spent half the year or more in storage. In time it was appreciated that owning and maintaining two complete sets of equipment was not very cost-effective. But in this *c.* 1900 scene, cost-effectiveness was a worry of the future for the trolley companies, and competition in the form of the automobile was not even imagined. (Raymond Library.)

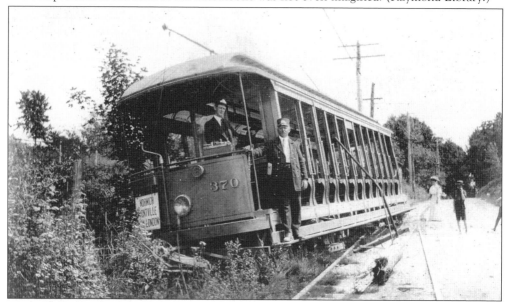

OFF THE TRACK ON THE NORWICH AND NEW LONDON TURNPIKE. In late 1904, the Montville Street Railway was merged into interests owned by the New York, New Haven & Hartford Railroad monopoly, emerging as part of its subsidiary trolley empire, the Connecticut Company. Here, a yellow-liveried Connecticut Company open car might have been going a bit too fast when it got into trouble somewhere on the rural Norwich–New London road. (Raymond Library.)

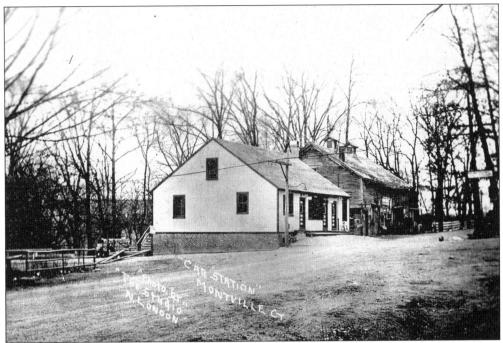

THE CAR STATION AT UNCASVILLE FOUR CORNERS. In this eastward-looking photograph, taken somewhat later than the one at the top of page 118, the original makeshift waiting room has been replaced with a more substantial building. The Uncasville post office was located here at one time. (Charles Dennis.)

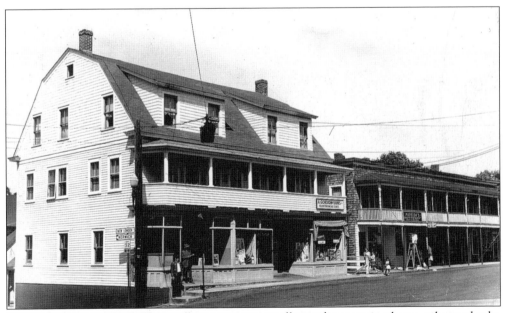

UNCASVILLE, C. 1940. The trolley car station still stands, more or less, underneath the addition of second and third floors. They were badly damaged by fire not so many years ago and were taken down and rebuilt with a different design. The block of stores and apartments seen on the right burned down at about the same time. (Montville Historical Society.)

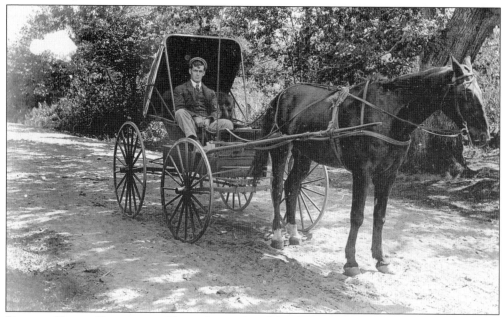

DOUBLE DUTY. Here we see Harry Auwood and his horse again, now on their own time. (They are also seen on page 61.) In 1909, owning an automobile was still well beyond the reach of most people. But in that same year, Henry Ford introduced his Model T, which was to become the car that everyone could afford.

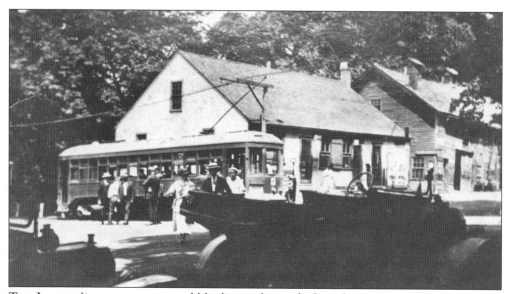

THE JITNEY. Jitneys, or taxis, would be lining the road when the trolley let off passengers at Uncasville Four Corners. Ed Glasbrenner's vehicles were Dodges, while Fred Crandall and the Yoselevskys operated Model T Fords. (Montville Historical Society)

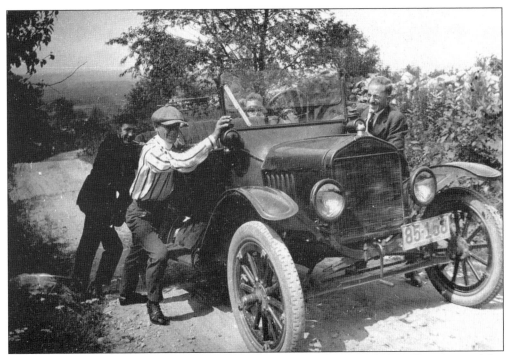

ON RAYMOND HILL. "On Raymond Hill, Sun. Sept. 5 1920," is penciled on the reverse of this Kodak snapshot, another of the great innovations of the day. This Ford Model T appears to be of the 1919 or 1920 production year. In all likelihood nothing was broken, but the locations of the gas tank and carburetor in the Model T ensured trouble on steep hills when fuel was low. After 1925, the old road up Raymond Hill from the south was reconstructed as part of the new Route 163. This view looks down toward Camp Oakdale.

AN IMPROVED ROAD, 1920s. Thanks to legislative initiatives, many substandard local roads were improved as state highways.

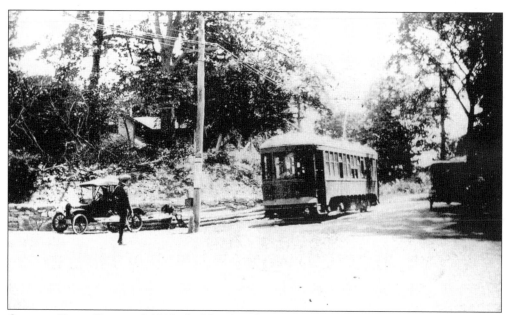

QUIETER DAYS. From mid 1913, the New London Division of the Connecticut Company was leased to the Shore Line Electric Railway for 99 years. Here, one of a batch of heavy steel cars delivered in 1915 rolls into Uncasville Four Corners from New London. Note the constable superintending traffic. Trolley service ended in 1936. (Charles Dennis.)

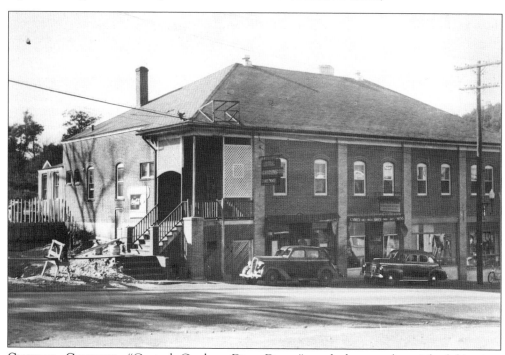

CENTRAL GARDENS. "Central Gardens Dine Dance" read the popular nightclub's sign. On the ground floor, at the Central Store, you could by shoes, clothing, and other dry goods. Montville Hardware occupied the corner; its sign is not visible here. At left, construction has just begun on the new Uncasville Post Office. (Montville Historical Society)

Seven
FACES OF MONTVILLE

People appear in many of the images in this book, but this chapter presents a small selection of photographs that were chosen for the variety of ways in which they reflect lives lived in a different time. Each image—perhaps much more so than a photograph of a vanished mill or a trolley car, an ancient house or a historic landscape—serves as a reminder that Montville exists today in a world transformed. In some ways, the past reverberates in Montville today for those who take the time to look and listen. But the glimpses seen here are gone forever.

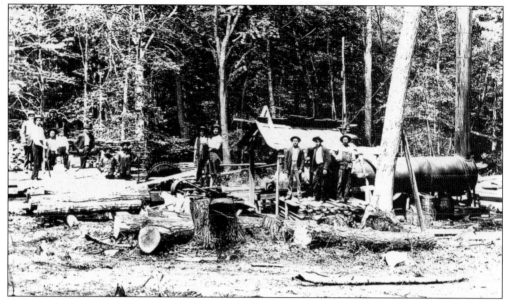

A STEAM SAWMILL. A steam-powered sawmill is at work somewhere in Montville. When the work in a given area was done, the mill, engine, and boiler could be dismantled and moved to another location. (Montville Historical Society.)

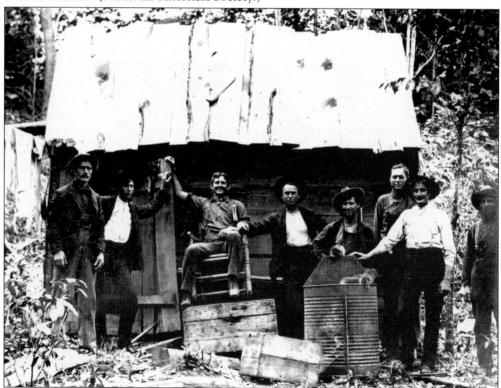

THE SAWMILL CREW. This crude shack must be the bunkhouse, given the underwear drying on the line. The well-dressed young man standing in the doorway, whoever his is, looks like he'd rather be somewhere else. In contrast, the others appear quite content. (Montville Historical Society.)

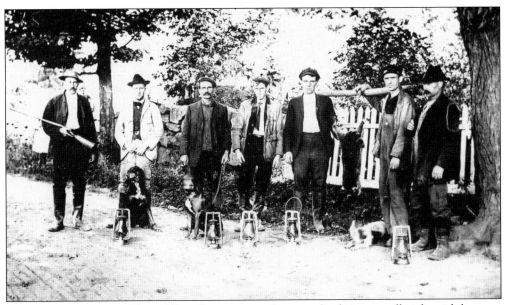

THE MORNING AFTER. These fellows have gotten a big one after being out all night with lanterns and 'coon dogs. A successful night's chase ended with a treed raccoon, then with the prize claimed. (Montville Historical Society.)

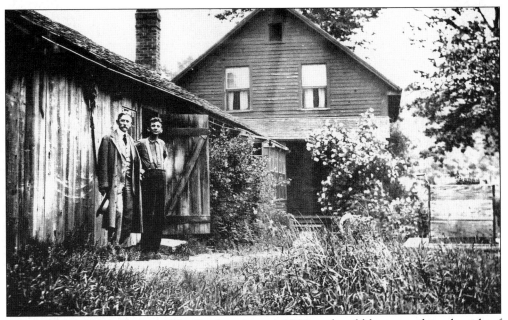

CHARLES AND FRED CHAPEL. The brothers pose *c.* 1900 at the old homestead on the side of Poles Hill. Near the close of the Civil War, this house was built by George Washington Hill, who, according to Henry A. Baker, "cleared up the land, and cultivated it; set out a fine orchard of fruit trees, and made a paradise in the wilderness." (Montville Historical Society.)

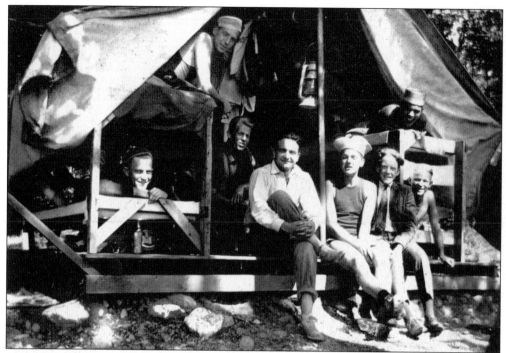

CAMP OXOBOXO, 1919. Over the years, a number of summer camps had their day in Montville. Camp Oxoboxo was situated on the northern side of the lake. In this scene, a group of young men seem happy to be out of the city, and they appear well settled in.

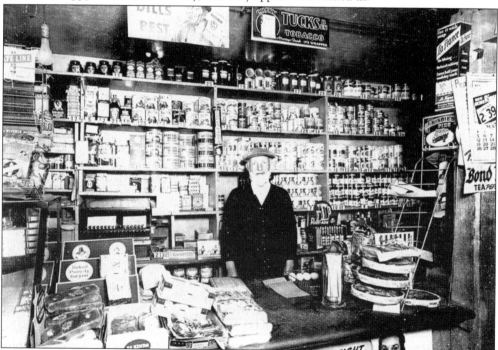

OAKDALE GENERAL STORE. Morris Yoselevsky is seen behind his counter. His son Isadore later owned the store for many years. (Montville Historical Society.)

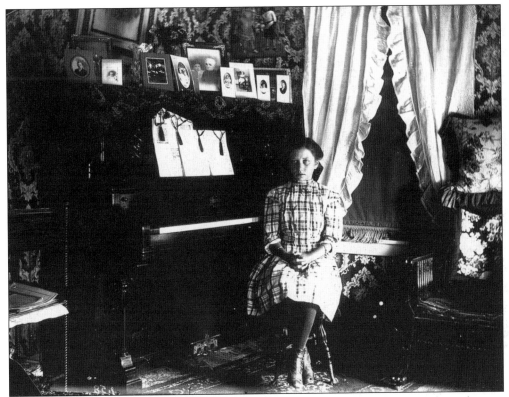

LILLIAN SAWYER. The contemplative young girl poses *c.* 1900. This must have been a respectable home, as evidenced by the presence of the piano. (Montville Historical Society.)

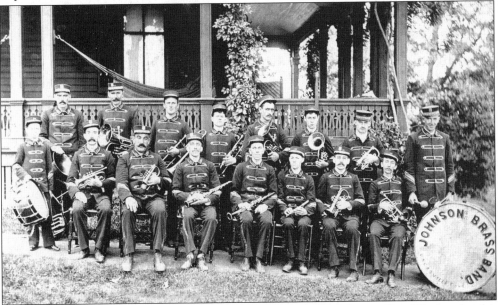

JOHNSON'S BRASS BAND. Henry C. Johnson purchased the Johnson Dye Works after his father's death in 1892. The backdrop of this photograph is the porch of his house at Uncasville, seen in the distance in the view on page 85.

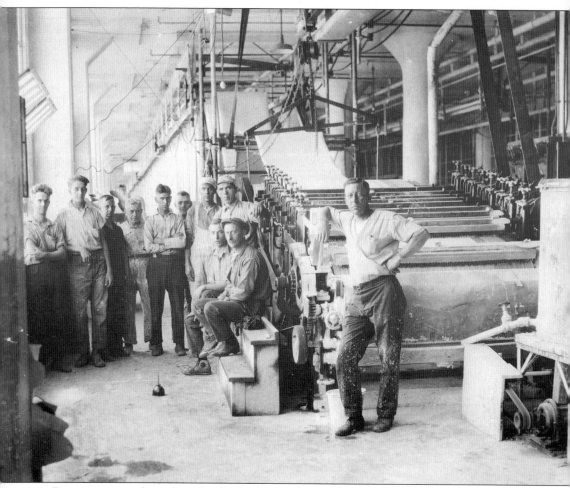

PAPERMAKERS. Coated stock appears to be the product in this scene at the Robert Gair Company, probably photographed in the 1940s. The Rockland Company first made paper in Montville in 1850. Will the trade be followed here for another 150 years? (Raymond Library.)